Images of Modern America

LGBT MILWAUKEE

Front Cover: Rugged, resilient, festive, and forward, the parade goer in this photograph (Jeff Zimmerman) embodies the spirit of Milwaukee pride. (Kraco Photography.)

Upper Back Cover: In this image taken by the author during the 2014 Milwaukee Pride parade, the "Love Wins" banner commemorates the landmark Wisconsin Supreme Court ruling legalizing same-sex marriage in Wisconsin. (Milwaukee Pride, Inc.)

Lower Back Cover: (from left to right): This trio features Josie Carter and Jamie Gays, two well-known LGBT elders whose participation in the Wisconsin LGBT History Project, Wisconsin Transgender Oral History Project, and other initiatives provides priceless historical perspectives. (Wisconsin LGBT History Project.); This Is It is now the longest-running gay bar in Wisconsin. This photograph shows it in its earliest days, when there was still exterior signage announcing the bar's location. (Wisconsin LGBT History Project.); B.J. Daniels, pictured with Tiffany Thomas, is a Milwaukee icon whose formative role in Milwaukee's drag and design scene spans three decades. (Chris Corsmeier.)

Images of Modern America

LGBT MILWAUKEE

Michail Takach
Foreword by Don Schwamb

Copyright © 2016 by Michail Takach
ISBN 978-1-4671-1728-9

Published by Arcadia Publishing
Charleston, South Carolina

Printed in the United States of America

Library of Congress Control Number: 2016932929

For all general information, please contact Arcadia Publishing:
Telephone 843-853-2070
Fax 843-853-0044
E-mail sales@arcadiapublishing.com
For customer service and orders:
Toll-Free 1-888-313-2665

Visit us on the Internet at www.arcadiapublishing.com

Dedicated to Vanessa Alexander

Contents

Foreword 6

Acknowledgments 7

Introduction 8

1. Before Stonewall 11
2. Time for Liberation 45
3. City of Night 65
4. Postmodern Pride 85

About the Organizations 95

Foreword

Those of us who grew up during the days of Stonewall know that the LGBT community did not gain the understanding and acceptance of society by accident. A buildup of awareness turned the tide on the parts of both the LGBT community and "straight" society. Even in an unplanned, disorganized fashion, our community took steps to raise awareness of our normality and our suppressed rights.

The Wisconsin LGBT History Project attempts to capture that history to provide a better understanding of the evolution of the Milwaukee and Wisconsin LGBT communities and how that evolution has led to greater acceptance and understanding.

I established the Milwaukee LGBT History website (mkeLGBThist.org) in 2003, compiling the initial content from 2004 to 2006. Since that time, it has been in a state of continual growth, as we attempt to chronicle the history of Wisconsin's LGBT community life along five major lines—businesses, organizations, people, media, and events.

In addition to the website, a large exhibit is created each year for Milwaukee's annual PrideFest celebration. This allows us to provide both a broad understanding of the community and focus on particular historical topics. These displays are also made available to other groups or events to exhibit throughout the year.

By buying this book, which reveals the early days of gay bars—how they were established and what impact they had—you help to support both the website and the PrideFest LGBT History Exhibit. This not only benefits the LGBT community, but also serves as a source of information for non-LGBT society to better understand the contributions and history of the LGBT community.

Aside from that, I know you will enjoy this book just for the anecdotes, the easy reading, and the historical photographs. Happy reading—and enjoy this journey down the streets of old Milwaukee from an LGBT perspective!

—Don Schwamb, founder and webmaster,
Wisconsin LGBT History Project

Acknowledgments

Every year, my family made a holiday trip to the downtown convention center. Year after year, buildings vanished along State Street, until finally only one was left standing: the tiny little Mint Bar. And then, one year, the Mint Bar was gone, too. Thirty years later, there is no evidence it ever existed.

A strange sort of amnesia sets in when we lose all sense of a place. First, we memorialize; then, we misremember; and finally, we forget. Without storytellers to carry forth our history, our culture and community can be lost.

The AIDS crisis robbed the world of a generation who would have been those storytellers today. As such, special thanks are owed to those surviving LGBT elders who remained true to their hearts and their community and proudly share their stories today. Their commitment and courage to lead an authentic life has been an inspiration and is the driving force behind this book.

My greatest appreciation also goes out to Don Schwamb and the Wisconsin LGBT History Project. This grassroots, not-for-profit community project is devoted to documenting the evolving face of local gay, lesbian, bisexual, and transgender life, far above and beyond the contents of this publication. Many of the recollections and photographs presented here are courtesy of that website.

I want to extend a warm thank-you to Milwaukee Pride, Inc., whose mission to educate both the general community and the LGBT communities about needs, issues, and various aspects of LGBT culture provides a forum to celebrate the history and accomplishments of LGBT people, and whose network will prove vital to the reception of this book.

It is my sincerest hope that my book honors Milwaukee Pride's noble work and is a lasting contribution to the histories it seeks to preserve and the stories it is dedicated to telling.

Special thanks are also due to Jamie Taylor; Bjorn Olaf Nasett; Melody Hendrickson; Larry Patterson; Bunny; Kate Sherry; Carole Pecor; Sheila Alex: Gregg Fitzpatrick; Jessica Daniels; Joe Brehm; June Brehm; George Prentice; Michael Horne; Bobby Tanzilo; Jen Pahl and the Milwaukee Public Library staff; Steve Shaffer and the Milwaukee County Historical Society staff; and Michael Doylen and the University of Wisconsin-Milwaukee Archives staff.

I send my sincere and humble thanks to Josie Carter and Jamie Gays, for everything you always were and will forever be. Your contributions to this book have been immeasurable.

Lastly, I want to thank my grandparents, great-grandparents, and other senior members of my family, with whom I spent countless childhood hours, for sparking my fascination for local history and keeping that reverence ablaze for four decades and counting.

Introduction

> Society at large faces a practical problem. It must decide how it is going to deal with the homosexual in its midst. Whether or not there are more homosexuals today than there once were, they certainly are more visible.
>
> —*Milwaukee Sentinel*, February 2, 1965

Milwaukee seems an unlikely place for gay liberation to flower before Stonewall. After all, being homosexual was illegal here before the word *homosexual* even existed. Sodomy was criminalized in the Michigan Territory in 1836 and remained illegal until 1983. By the time of Oscar Wilde, Milwaukee was already a booming German Athens of industry, commerce, and a quarter million people.

Originally used to describe single-gender settings, *homosexual* aptly described male life in 1892. Milwaukee was a workingman's destination, with more single, able-bodied men arriving every day to make their fortunes. From rooming houses to railroads, from barrooms to bathhouses, and from factories to freighters, these workers lived in almost exclusively male settings.

For a homosexual man, it was actually easier to disappear into this hypermasculine culture than endure small-town family obligations. But, aside from the occasional Oscar Wilde Reading Room or the rare red-light alley bar, there were no defined spaces for gay men. Gay gatherings were behind locked doors in private homes or hotel rooms. Being homosexual meant living a mostly heterosexual life filled with desires that may be very, very discretely acted upon, but rarely, if ever, acknowledged.

Tracing gay and lesbian history is a challenge. Unlike ethnic or cultural heritage, LGBTQ history is not passed down from generation to generation. Family trees do not favor "funny uncles" or "spinster aunts."

You cannot easily search LGBTQ history online, unless you use the derogatory terminology of earlier times. When *gay* had a very different meaning, gay men were usually described as "sexual deviates." Stringing together innuendo, connotations, and keywords, you will find a pattern of where, when, and how gay men gathered in the early 20th century. Regrettably, these gatherings were only known for their scandal, and their participants for their dishonor. Gay pride was an oxymoron. "Known" gays were only known through shaming.

Consider, if you will, the men apprehended at Bradford Beach in 1947, shamed with names and addresses printed in the local paper, alongside their state penitentiary sentence for "morals charges." Or the teachers arrested for "disorderly conduct" at Schuster's Department Store on North Third Street in 1958, fined $100 each, fired from their jobs, and committed to mandatory psychiatric care. Or the graduate student booked for "indecent suggestions" in the Royal Hotel restroom in 1959, who lost his driver's license, military benefits, college degree, and future in one moment.

Consider Elroy Schulz, brewery worker, who was arrested in Juneau Park in April 1960 after supposedly grabbing a vice officer and making an "immoral proposition." A divorcee and ex-convict with a sodomy record, Elroy already had the odds stacked against him. He now had the misfortune of meeting the police department's boxing champion. Vice squad detectives claimed that the culprit resisted arrest. In the process of being "arrested," Elroy suffered shattered dentures, diabetic

shock, abdominal bleeding, and a brain hemorrhage—although the officer claimed to have hit him only once. Schulz died before sunrise, less than five hours after his discharge. His killers were cleared of charges of excessive force. "The officer acted justifiably and excusably in the due process of the law and could not be held criminally responsible," reads the inquest. "No charges will be filed." There were no protests, riots, or civil lawsuits for Schulz. People were more likely to congratulate the officer for removing another homosexual from the streets.

"People can't understand a problem they don't see. We see them – these men are predatory. They hang around theaters, stores, and public restrooms. They are a threat to public decency," said a veteran police officer.

Elroy Schulz's death was a chilling reminder that gays could expect no mercy. They were already bombarded with media messages that they were indecent, immoral, and dysfunctional. They were considered second only to prostitutes as a public-health risk. They were threatened with being institutionalized until proven "cured" of their sexual orientation. "For most of the hidden homosexuals, it is a furtive, lonely life of passing attachments, a life haunted by fear of exposure, loss of job, blackmail and perhaps guilt. It is gay only in homosexual jargon," reads an article in the *Milwaukee Sentinel* in 1960.

A great awakening of sorts happened in Milwaukee in the early 1960s. Rather than being scared into hiding by police brutality, criminal records, or social shame, Milwaukee's gay subcommunity emerged as a community. "If we were going to hell anyway," said a contributor, "we were going to hell in high heels. Let nothing more stand between us and our fun." "They now want it believed that homosexuality is not just an acceptable way of life, but rather a desirable, noble, preferable way of life," remarked the *Milwaukee Journal* in May 1964. "The homosexual has gotten bolder."

By 1963, new bars began to appear in surprising places: coal-stained flour mills and abandoned hotels on the South Side, desolate warehouses in the Haymarket, racially mixed taverns in the inner city. The 1963 *Lavender Baedeker Guide* lists 12 known gay venues in Milwaukee, including four hotels, two restaurants, and six bars—including the Mint Bar, open 20 years before Stonewall, but becoming less "mixed" every day.

Who took the risk of funding these early gay bars? And why? Some were smart businessmen taking a serious gamble. Most were far more organized and strategic.

"Based on reports my vice detectives have given me," said Chicago Police commander John McDermott in April 1964, "the Midwest crime syndicate is exploiting homosexuals." With vice squads making strip clubs and B-girl bars less profitable, the Cosa Nostra needed a new source of revenue. By capitalizing on underserved gays and lesbians, the Mafia became an unlikely founding father of America's gay bars. Through quiet arrangements with local police, syndicate bars reportedly received advance notice of raids, relaxed enforcement, increased protection, and smoother license processing.

These "bust-out" bars were shadowy experiences with a hint of danger. Except for a 12-by-12-inch door panel required by law, they had no windows. People still faced real consequences just for being seen at a gay bar. Cameras were not exactly welcome in these places, because only the brave few wanted to be known as customers. In light of this, the existence of 1960s and 1970s nightlife photographs is shockingly priceless.

For most of the 1970s, 1980s, and 1990s, Milwaukee sustained over two dozen gay bars at once—a surprising amount for a city of our population. Eighty years after the Royal Hotel Bar attracted a "lavender reputation," its descendants continue to make local history in a world of sweeping social change. But we cannot, in a nation of marriage equality, pride parades, and cruising apps, imagine the bravery it required to be your best self in an earlier America.

This book is dedicated to those whose history cannot be told because it could never be known; to those whose lives were forever filled with the anguish and anxiety of being "found out"; to those whose lives ended in shame and self-loathing because they were. We raise a glass to you and the places where you found hope and happiness.

And we remember.

One

BEFORE STONEWALL

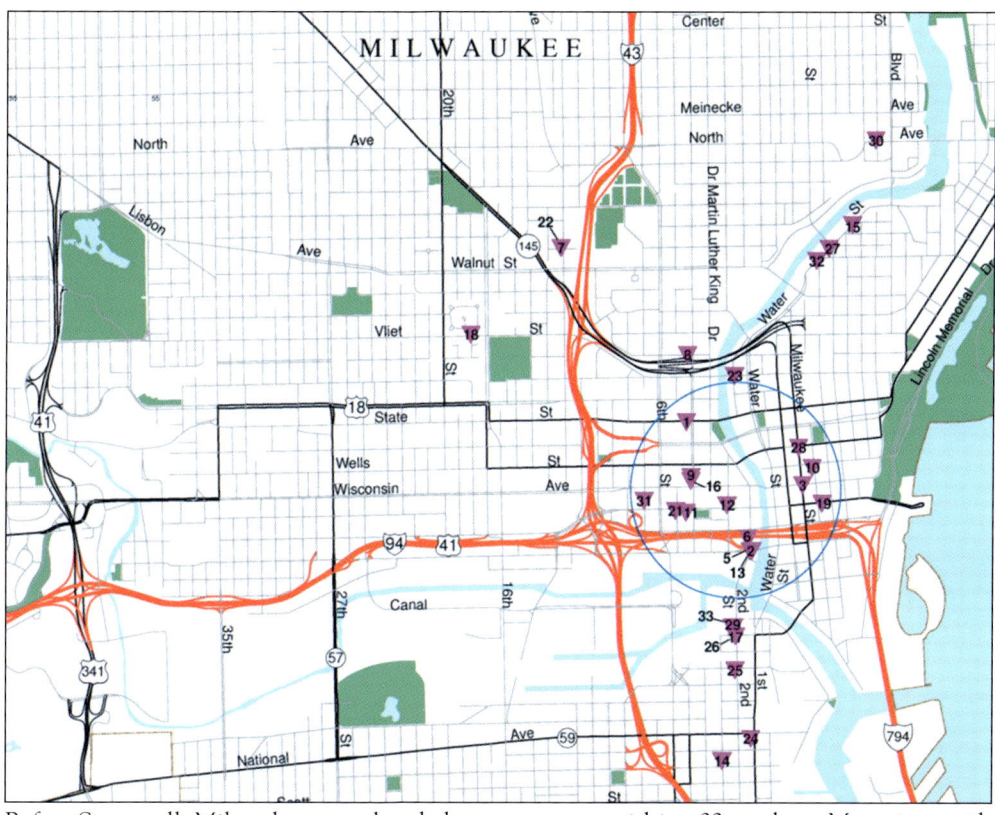

Before Stonewall, Milwaukee was already home to an astonishing 33 gay bars. Mysterious midcentury nightspots like Wildwood (1430 West Walnut Street), White Horse Inn (1426 North Eleventh Avenue), the Bridgeport (3762 North Green Bay Avenue), Godfrey's (1800 West Vliet Street), the Pink Pony (1834 West North Avenue), Clifton Tap (336 West Juneau Avenue), and Pink Glove (631 North Broadway) welcomed sunset lovers lucky enough to locate them. To avoid busts or blacklisting, these bars advertised in clandestine code: "If you're one of those fancy fellows who fancies pink squirrels, we hear they make them up nice at the Pink Pony," teased a 1953 *Milwaukee Journal* nightlife column. "You'll find it on the shady side of the street." Today, not a trace remains of these seven historic landmarks. (Wisconsin LGBT History Project.)

11

One of the earliest and longest-running gay meeting places in Milwaukee was also most unlikely. From 1882 to 1911, Kitty Williams operated an elaborate 42-room bordello at 219–221 East State Street, not only in the shadow of Milwaukee City Hall, but rumored to be *connected* by secret tunnel. Complete with marble baths, running fountains, and a Louis XIV room with a golden throne, the Kitty Williams house was, curiously, both a regional sporting guide attraction and a rendezvous spot for "gay blades out for a fling." After the house officially closed, Kitty operated several businesses here, including a tavern with a reputation for serving "deviates." Kitty died in 1943. Her properties were demolished in a 1963 renewal project that created today's Red Arrow Park. (Wisconsin LGBT History Project.)

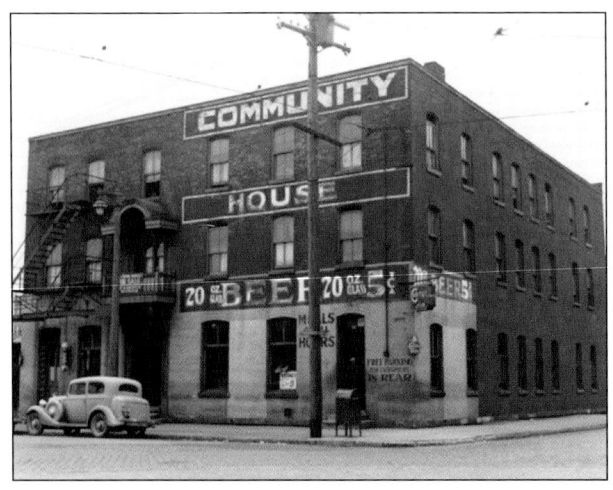

Low-cost, male-only housing was a booming business in early Milwaukee. By the 1940s, these hotels had become notorious flophouses. With its cheapest rooms walled only with chicken wire or beer crates, the Community Hotel (117 East Seeboth Street) was the end of the road for Milwaukee's unwanted men. Frequently raided for spreading tuberculosis, venereal disease, and "deviate" activity, the hotel was demolished in 1961. (Historic Photo Collection/Milwaukee Public Library.)

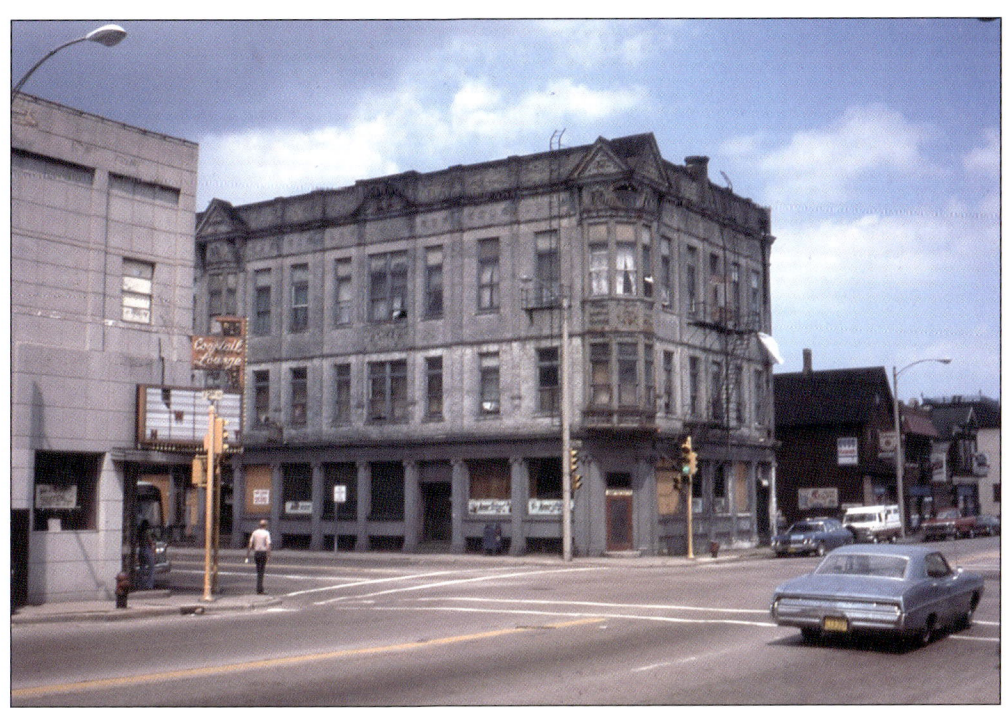

For 99 years, the German American Bank (734 South Second Street) anchored the intersection of Second and National Streets. The bank did not survive the Great Depression, but the landmark building remained a gay-friendly rooming house for decades. On September 10, 1986, the vacant building was destroyed by arson in a 13-hour, five-alarm fire requiring 125 firefighters, five engines, and six ladder companies. (Milwaukee County Historical Society.)

How did gay men meet when approaching each other was difficult and dangerous? "You went to the bus or train station. You watched, you waited, and you followed someone out," said one contributor. The Park Hotel (545 North Fourth Street), only footsteps away from the Milwaukee Road Depot and Public Service Building, offered a circular bar and clandestine cover stories until 1974. (Milwaukee County Historical Society.)

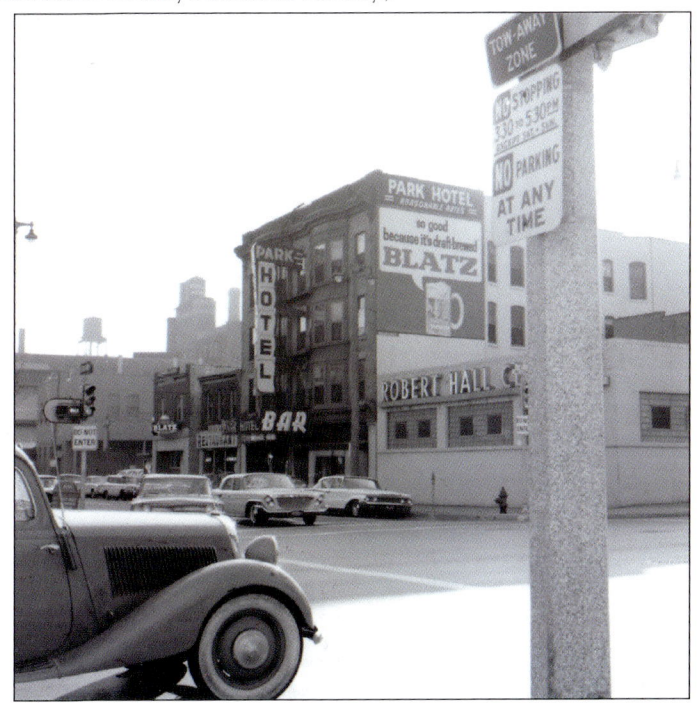

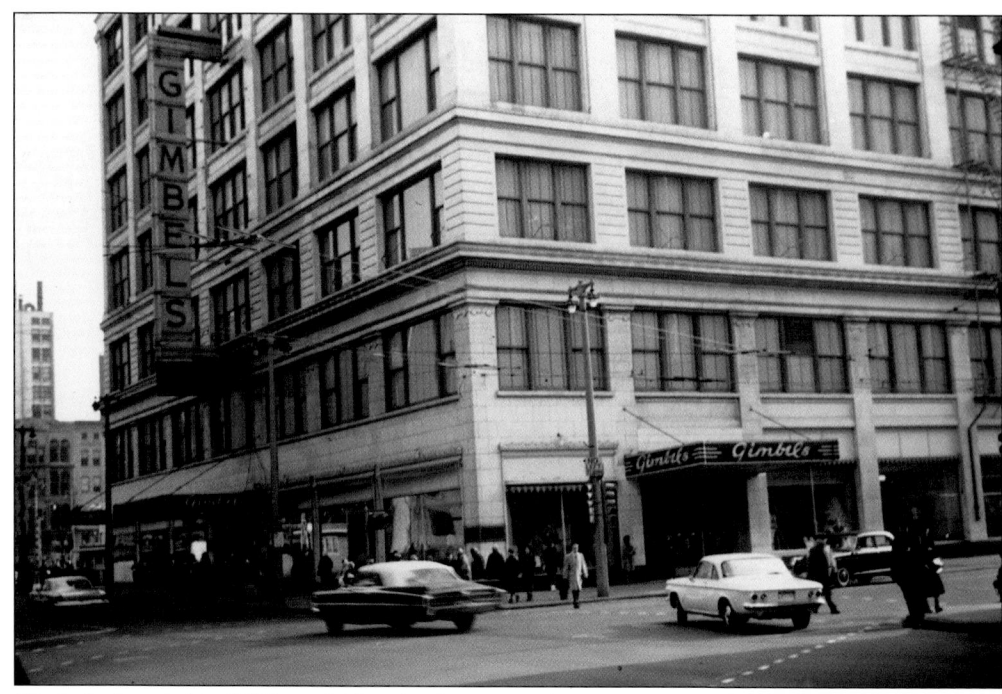

Gimbels, founded in 1887, was Milwaukee's premier department store for almost a century. By the 1950s, its fifth-floor restroom was already known as a men's meet-up spot. Initially, there was a low risk of being arrested in a store restroom. As enforcement increased, men stood in shopping bags to conceal themselves. For years, gay men shopped for more than records at Gimbels. (Historic Photo Collection/Milwaukee Public Library.)

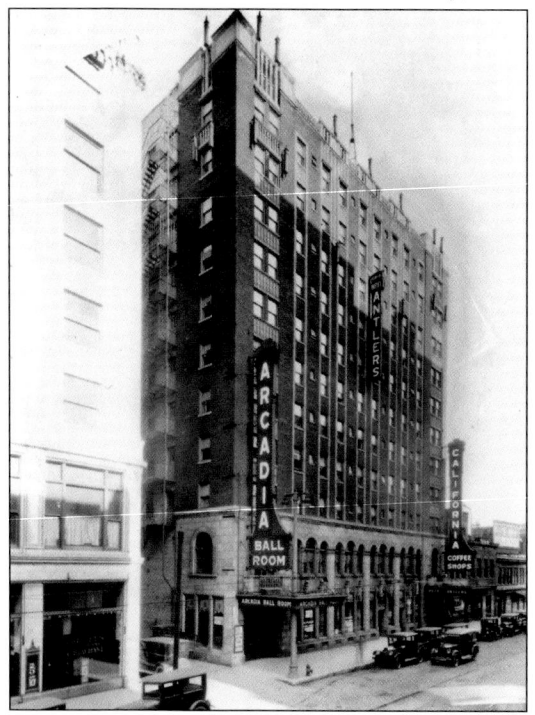

"Bring the ladies," pleaded 1924 ads for the men-only Antlers Hotel. The new hotel was a gentlemen's paradise, offering not only 450 fireproof rooms under $2 per day, but also 16 bowling lanes, a 20-table pool hall, golf course, boxing arena, coffee shop, barbershop, cigar lounge, and table tennis courts. It was the second-largest hotel in Milwaukee. Filled with 11 floors of single men, usually sailors, the Antlers quickly became a place for gay cruising. In October 1980, the Antlers Hotel was demolished for Grand Avenue parking. (Milwaukee County Historical Society.)

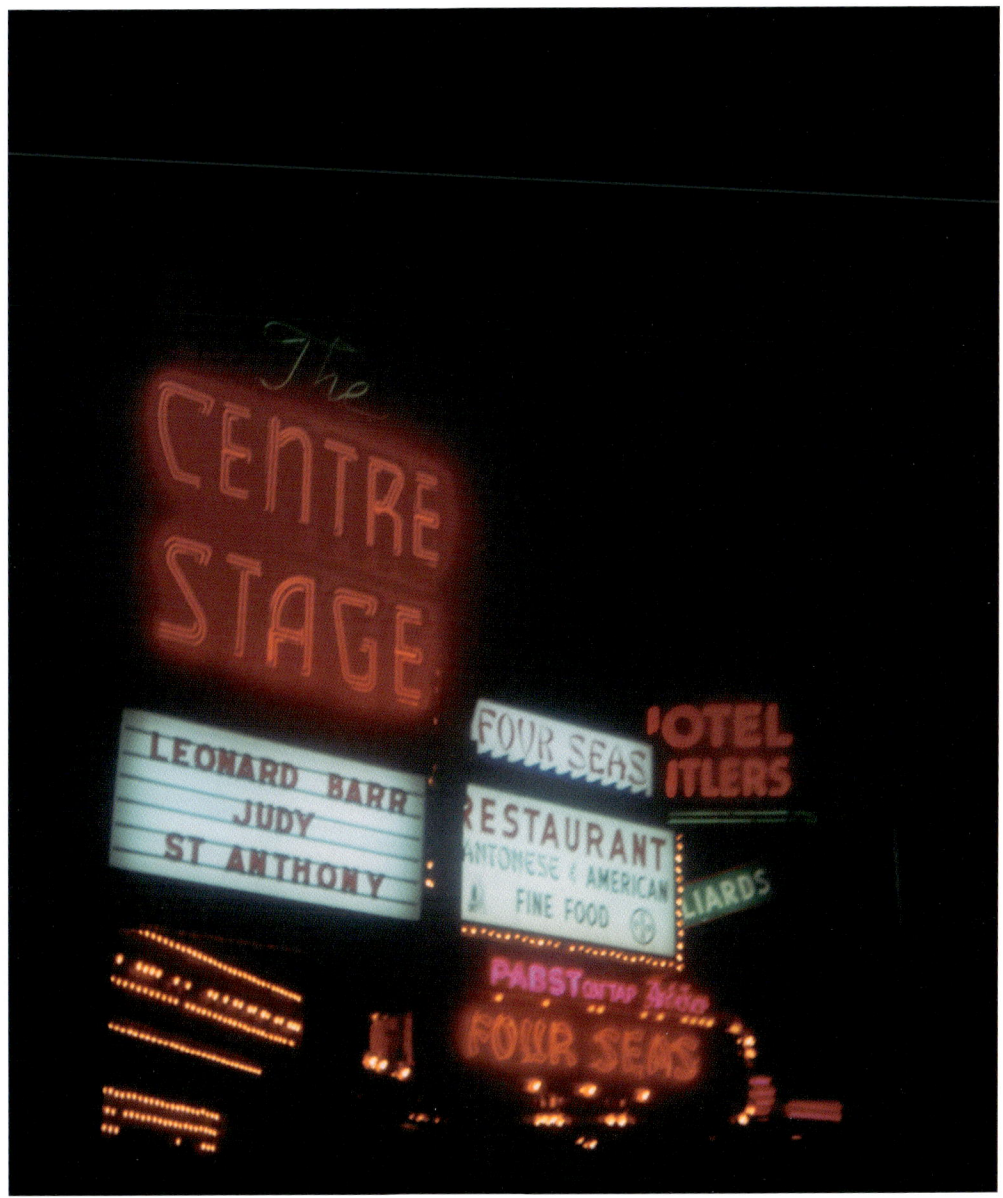

Between 1932 and 1947, the Antlers Hotel Futuristic Ballroom hosted the best in big band orchestra. Through the 1950s, the space was known for sporting events and sock hops. On December 31, 1961, Ray Boyle, director of the Fred Miller Theater (now Milwaukee Repertory Theater) unveiled the 700-seat Swan Theater and supper club. "The Antlers Ballroom had that worn look that comes with growing old gracelessly," noted the *Milwaukee Sentinel*. "If you returned New Year's Eve, you found a miracle." The miracle lasted three seasons. Buried in debt, the "dying Swan" closed in December 1964. In November 1965, the Balistrieri family opened a brand-new concept. The Scene nightclub hosted the hottest acts of the 1960s, including Jimi Hendrix, Frank Zappa, Miles Davis, and Steppenwolf, as well as go-go dancers and risqué films. In September 1972, the Centre Stage replaced rock shows with Broadway dinner theater. Headliners included Bob Denver, Cesar Romero, Rosemary Clooney, Martha Raye, and Carol Channing. It was also the original venue for the Miss Gay Wisconsin pageant. (Milwaukee County Historical Society.)

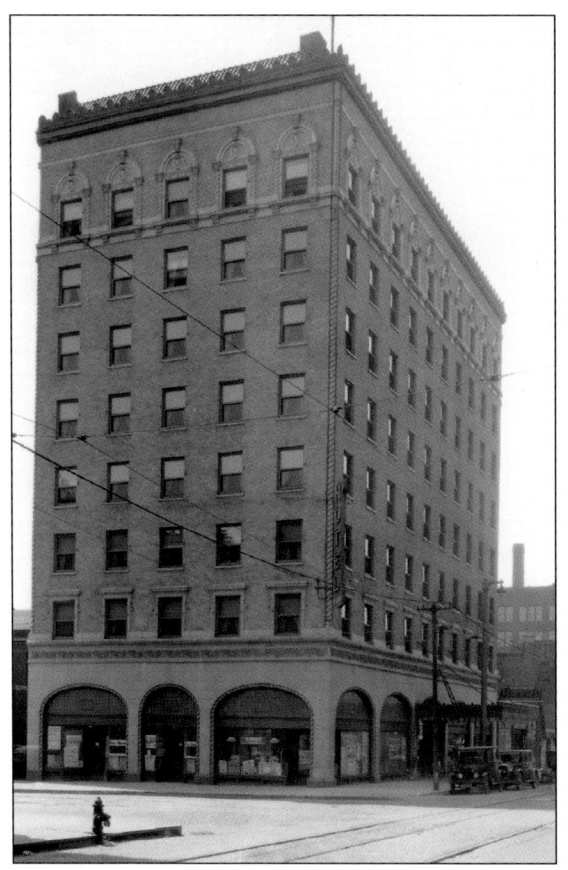

From opening day on February 27, 1926, the Royal Nixdorf Hotel (435 West Michigan Street), was a girl down on her luck. Original owner Ernest T. Nixdorf lost the hotel in the Great Depression, his daughter to an alienation lawsuit, and his wife to a self-inflicted gunshot. Reopening as the Royal Hotel in 1929, the 138-room lodging was the scene of continuous police activity. When runaway girls went missing, they were often found at the Royal. When bank robbers, liquor runners, and drug dealers were apprehended, they were usually caught at the Royal. When "deviates" were arrested, it was usually in the basement restroom of the Royal Hotel. After the 1931 closing of the St. Charles Hotel in City Hall Square, the Royal inherited its manager, staff, and reputation for relaxed morals. By the mid-1930s, gays and lesbians began to gather informally at the hotel cocktail bar and café, taking advantage of an open, accepting atmosphere. The bar manager openly provided financial and civil support for anyone arrested in "bathroom busts." (Milwaukee County Historical Society.)

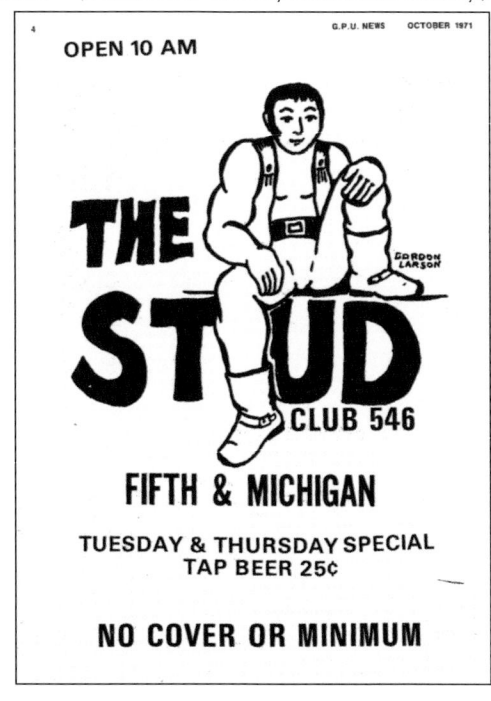

By 1968, the Royal was so derelict that the Milwaukee County Board sought to convert the hotel into a jail. Plans collapsed, and the Royal was sold in 1969. Eager to change the hotel's image, the new owner renamed it the Buckskin Inn. After $100,000 in renovations, the Buckskin still did not attract new clientele. The building was sold at sheriff's auction in 1971 to Western Bank, which narrowly outbid the Balistrieri family. The lobby bar was rebranded the Stud Club in 1971 and Michelle's/Club 546 in 1972. Michelle's was incredibly popular, offering variety shows, go-go dancers, polka parties, drag balls, and a 24-hour café. But Milwaukee officials began redevelopment negotiations in 1970, and finally agreed on terms with Blue Cross Blue Shield in 1973. Michelle's closed on September 23, 1973, when guests received keys to their most memorable rooms as parting gifts. The hotel was flattened in 1974. "So there goes the shabby old Royal Hotel, and good riddance," noted the *Milwaukee Journal*. "That's the best kind of blight elimination." (Wisconsin LGBT History Project.)

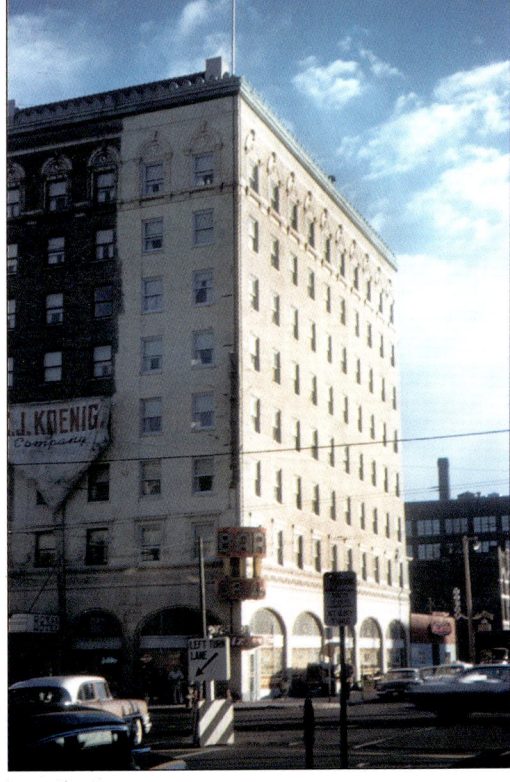

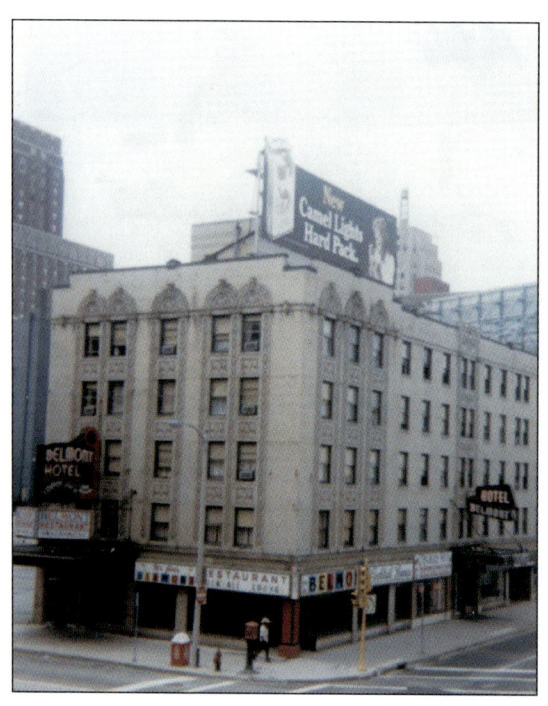

For 70 years, the Belmont Hotel (751 North Fourth Street) stood at Fourth and Wells Streets. "In the heart of the city, those who patronize the Belmont will be afforded unusual opportunities," promised opening-day ads on October 7, 1926. They were right. Its block-long Belmont Coffee Shop was a "headquarters for night people," including actors, burlesque dancers, gamblers, hustlers, hippies, and B-girls. "I walked in nude with a mink stole dragging behind me," said a contributor. "No one blinked." The Belmont Café was frequently listed in gay guides, as was the neighboring GayTime Bar (731 North Fourth Street). "The Belmont was never a classy hotel," said the *Milwaukee Journal*, "but it's always been a survivor." Bullied by developers for decades, the battered Belmont was demolished in 1996. (Milwaukee County Historical Society.)

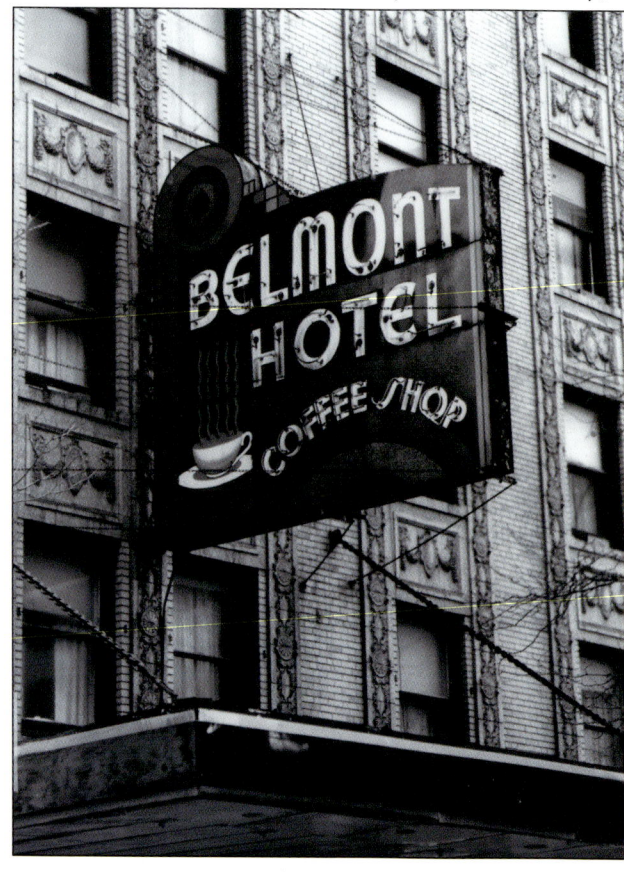

The Legion Bar, located on North Sixth Street between Wisconsin Avenue and Wells Street in the shadow of the Wisconsin Tower, was one of a thousand downtown taverns of its time, but it was the only one known to have an active gay backroom ("just behind the jukebox") as early as the 1930s. Angelo Aiello, later of the Mint Bar, worked here in the 1950s. (Milwaukee County Historical Society.)

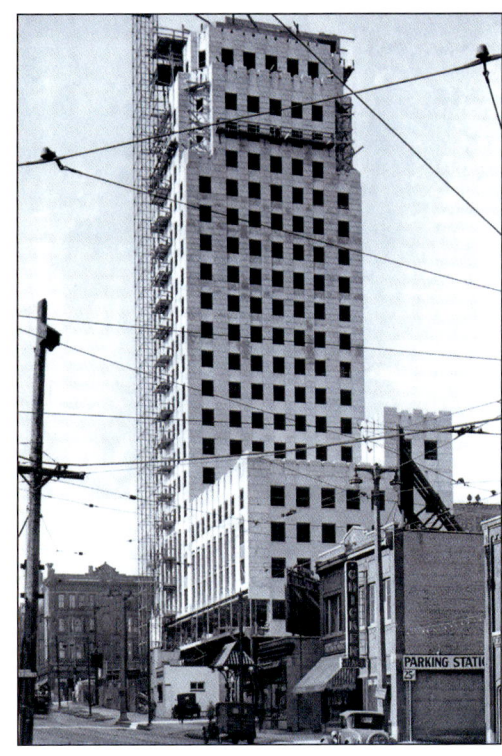

The Loop Café (603 North Fifth Street) was not just another greasy spoon. Throughout the 1960s, it was one of three downtown diners—including the Belmont Coffee Shop and Marc's Big Boy—where gays and lesbians of all ages connected. "Everyone knew we had our own section," said a contributor, "and anyone who sat in that section was fair game." (Milwaukee County Historical Society.)

North Third Street between Wisconsin Avenue and Wells Street was Milwaukee's adult playground, with burlesque clubs, dance halls, restaurants, and almost a dozen movie houses. By the 1960s, North Third was a red-light district better known for adult theaters, strip clubs, and porn stores. Visiting sailors were warned away from the Hotel Wisconsin and Towne Hotel for more reasons than one. (Milwaukee County Historical Society.)

The Red Room, inside the Plankinton Arcade (161 West Wisconsin Avenue) is well known for launching Liberace's career in 1937. With 60 pool tables, 41 bowling lanes, and an 83-foot cocktail bar, Red Room (a.k.a. "Bed Room") was a hook-up spot for decades. Cruising was so prevalent that management began charging for restroom use. This changed nothing. The Red Room foreclosed in 1960. (Milwaukee County Historical Society.)

Built as a Pabst saloon in 1897, the Princess Theater (758 North Third Street) opened December 16, 1909, pledging to serve a "better class of people." After 1960, the Princess served fans of adult movies, including men seeking men. However, police raids focused on film content, not audience conduct. "The tearoom trade is alive and well at the Princess," said a police informant in 1976. Cashier Violet Clemons told *the Milwaukee Sentinel* in 1982: "A lot of guys aren't married, will never marry . . . [police] should keep their nose out of it." Not just the last X-rated theater, the Princess was also the oldest operating theater in Milwaukee. Last-minute preservation efforts ended when an "accidental" hole was punched into the theater. With no other option remaining, the Princess was razed in 1984. (Milwaukee County Historical Society.)

Juneau Park, among the oldest of Milwaukee's city parks, was dedicated in 1872 as a "breathing lung" to the congested industrial city. However, Yankee Hill's wealthiest residents opposed planting any foliage that would obstruct Lake Michigan views. Originally, the Chicago and North Western railroad tracks ran along the bluff, but wooded trails to Lower Juneau Park were added in the 1930s. By 1959, Yankee Hill's Victorian mansions were being replaced by apartment buildings, and Juneau Park had become a shaded, shadowy refuge. Following a sensational 10-man bust in Waukesha's Frame Park, Milwaukee Police became obsessed with an "undesirable" and "potentially dangerous" pattern. Between 1962 and 1963, one-fourth of the city's disorderly conduct arrests happened in Juneau Park, all of those involved "abnormal" sexual activity, and the number was growing every month. (Milwaukee County Historical Society.)

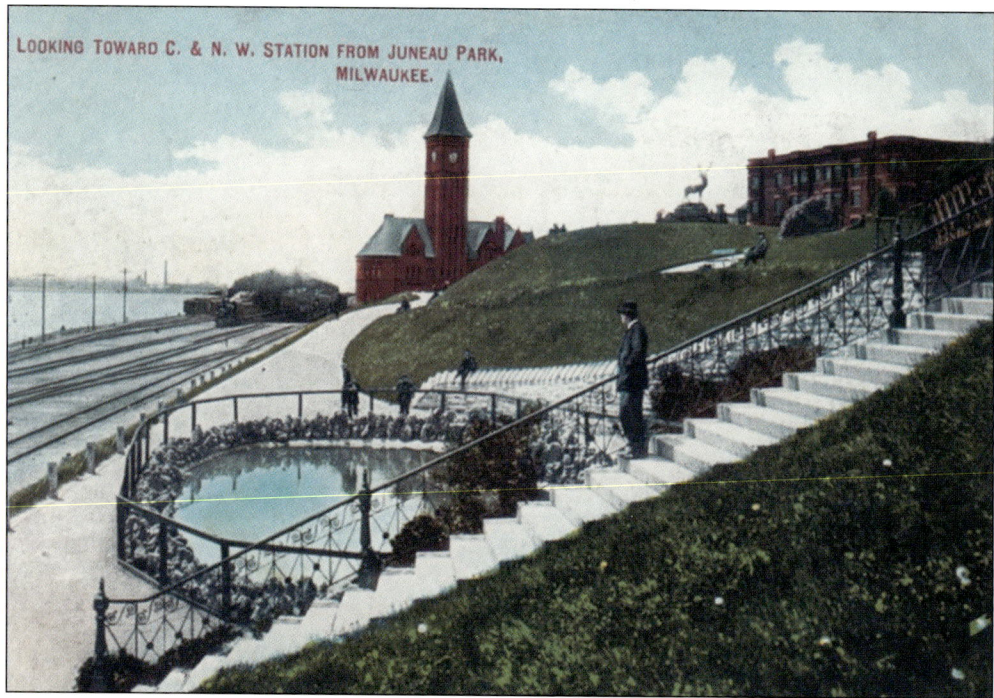

"Juneau Park has become a hangout for homosexuals," said MPD sergeant Walter Heller. "One of the sad results is that it has attracted young persons drawn out of curiosity. This could result in them becoming a sex deviate." Judge Christ T. Seraphim called for a public "war on perversion," pledging to "make the park safe for children." Up to 24 undercover detectives patrolled the park nightly, and their tactics unfortunately involved entrapment, coercion, and violence. "Stay out of Juneau Park—it's hot!" was often heard, but the temptation of "breakfast, lunch, and dinner" often conquered common sense. The LGBTQ community ultimately reclaimed Juneau Park, which hosted the city's first "Gay In" in 1973 and PrideFest from 1991 to 1994. When hookup culture moved online, all twilight traffic vanished from the park. (Milwaukee County Historical Society.)

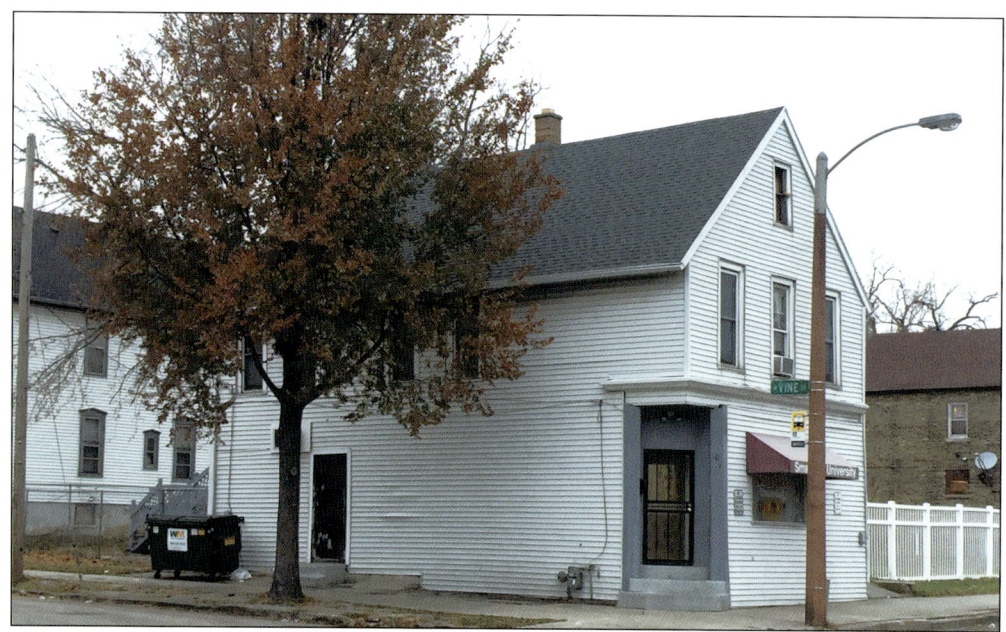

Located 11 blocks north of Marquette University's Gesu Church, the Forum (1801 North Twelfth Street) is remembered as an adventurous piano bar with a selective clientele. Referred to as "Twelfth and Vine" in code, the Forum (later known as the Pirate's Den) served almost exclusively white, professional, middle-aged men from 1959 until the race riots of 1967 and a casual, mixed crowd until closing in 1972. (Photograph by author.)

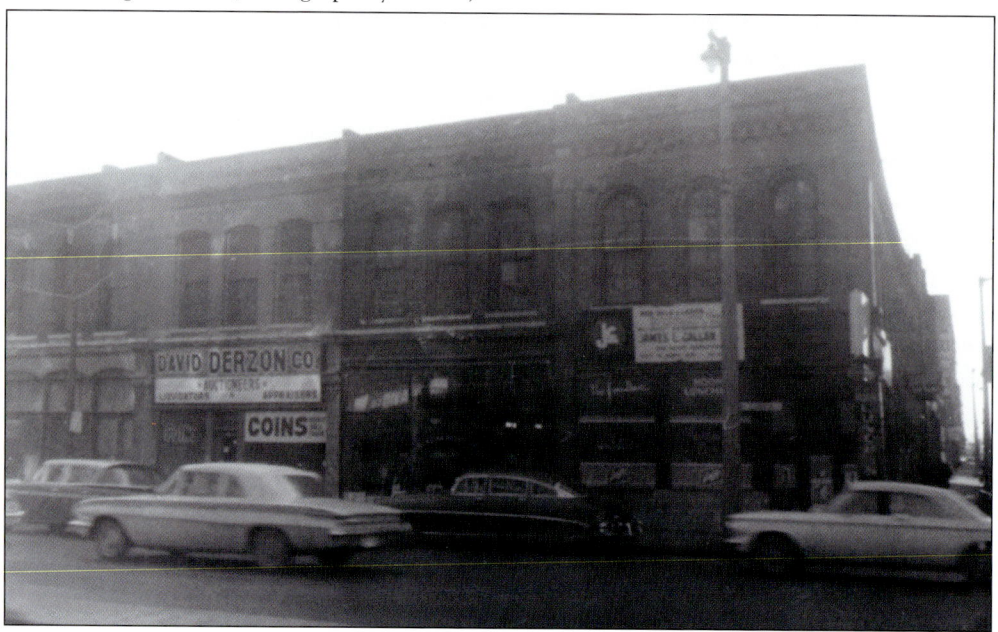

Under a cloud of condemnation since World War II, and long committed as expressway right-of-way, the 400 block of North Plankinton Avenue was murky by day and even murkier by night. Opened in 1948, the Fox Bar (455 North Plankinton Avenue) was famous for wild drag shows on its card table runway, until razed for I-794 construction in 1965. (Milwaukee County Historical Society.)

When Castaways (424 West McKinley Avenue) opened in 1962, the Haymarket area was so desolate that patrons would drag race down city streets. "We once drove a motorcycle straight into the bar," remembered a contributor. With painted-over windows, tiny red lights, and a "Bar" sign outside, no one suspected the hottest gay nightclub of its time was inside. Even today, few can believe it actually existed. First a piano bar and later a nightclub, Castaways debuted the Midwest's largest gay dance floor before men could legally dance together. Always prepared for a police raid, the DJ would brighten the backroom lights to warn dancers to separate. Displaced by Park East freeway construction, Castaways moved to 196 South Second Street in 1969. Never quite the same, Castaways South closed in 1972. (Both, courtesy of the Wisconsin LGBT History Project.)

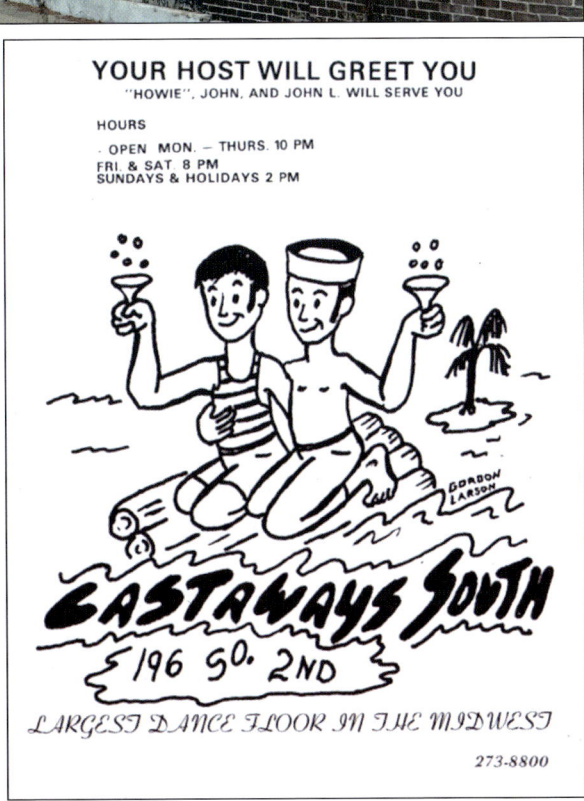

25

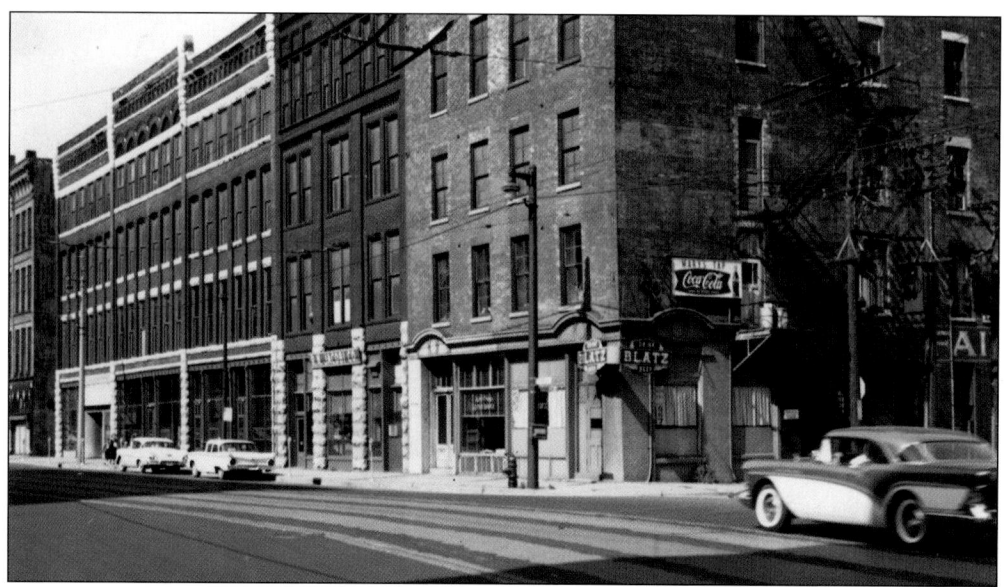

Built by George Burnham in 1853 as a grain elevator, the old coal-stained flour mill at 400 North Plankinton Avenue was owned by manufacturers Fairbanks, Morse & Co. when it became a gay nightspot a century later. Located at a dead end, when St. Paul Avenue ended at the Milwaukee River, the Old Mill Inn reopened as Mary's Tavern in 1958. Owner Mary Wathen later revealed that she opened the bar against her will, pressured by flamboyant financier Harry Kaminsky, whom over 200 local bar owners were indebted to. Wathen was constantly "bothered" by homosexuals, but Kaminsky ordered her to cater to them. "He said, 'if we can't beat em, let's join em,'" said Wathen. "They drove customers away." Mary's Tavern was sold in 1959, and Kaminsky later faced federal fraud and forgery charges. (Historic Photo Collection/Milwaukee Public Library.)

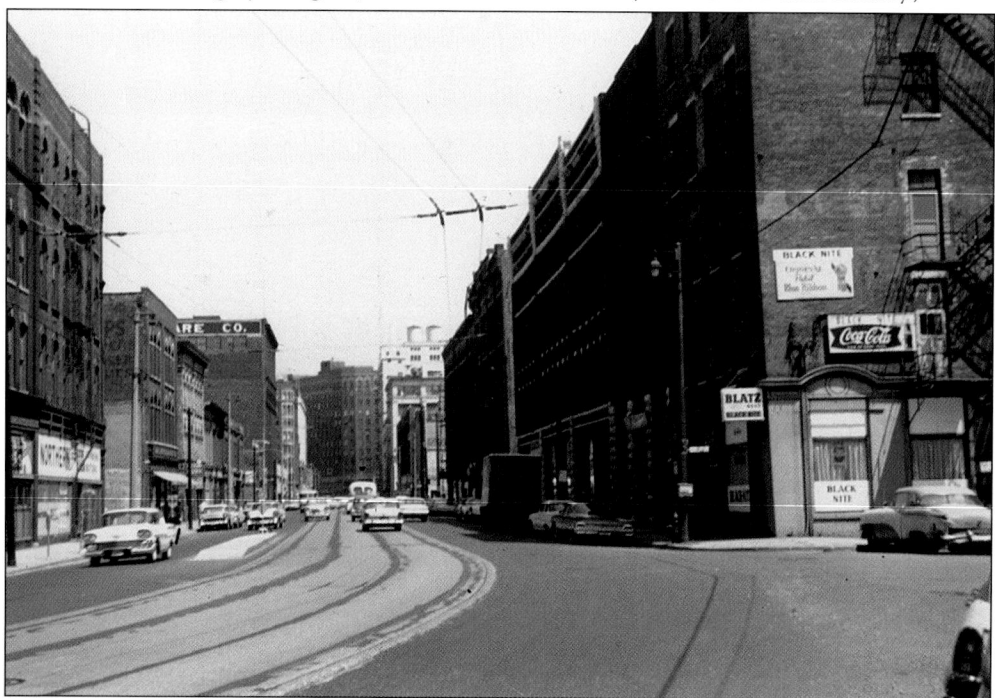

In 1960, Wally Whetham reopened Mary's as the Black Nite to celebrate its gay customers. Patrons remember a more protective police presence than at other bars. On August 6, 1961, Black Nite was the scene of a sensational bar brawl. When a serviceman was thrown out of the bar, he returned with friends, looking for a fight. They found 74 customers ready and willing to defend their turf. "My boyfriend was a bouncer," said Josie Carter, "and we did not run from a fight. We didn't start anything, but we sure as hell finished it. I could fight an Army off in a bathrobe." The Black Nite relaunched as Bourbon Beat from 1963 to 1966, when the building was razed for St. Paul Avenue's extension. (Both, Wisconsin LGBT History Project.)

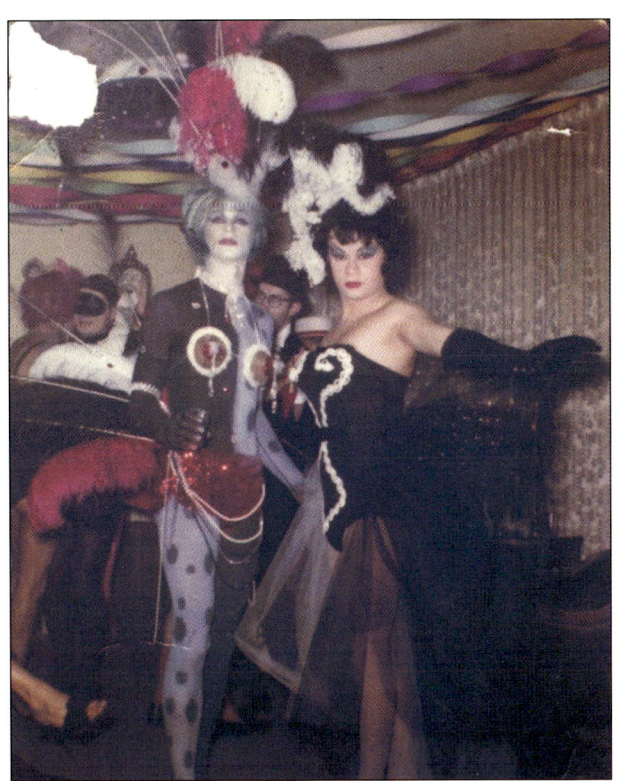

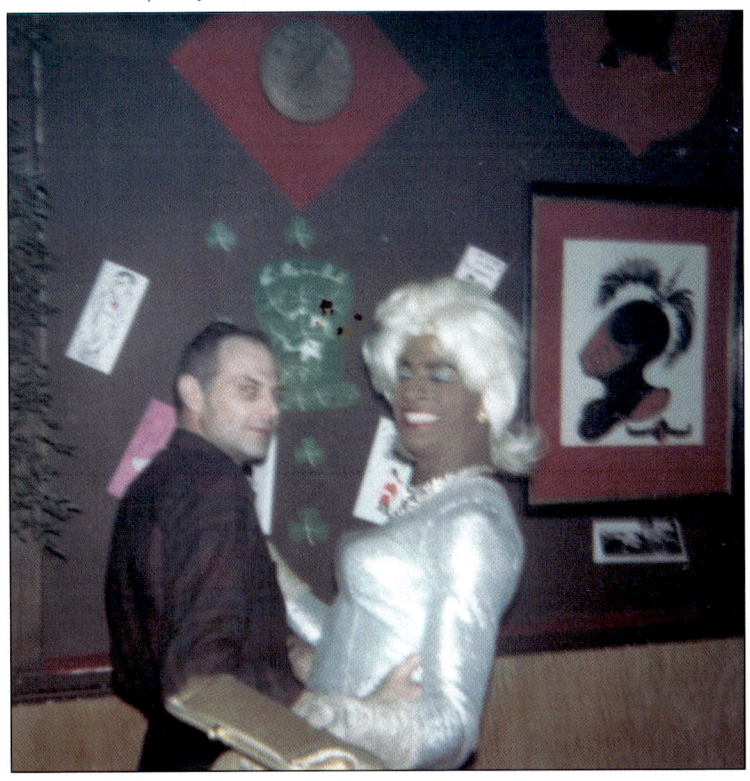

The Anchor Inn (401 North Plankinton Avenue), located in the historic Hunkel Seed building, was already an unofficial gay meeting place by the 1950s. In 1952, the 3,000-square-foot tavern was leased to Peter Machi of the Old Third Ward family, who opened Tony's Riviera Cocktail Lounge. Tony's Riviera became quietly known as the premier gay bar of the 1950s. The Machi brothers invested considerable money—and involved many sponsors—while carving a modern lounge out of the historic grain mill. "On Sunday afternoons, the place was loaded with cops," said one contributor. "Sometimes, they'd bring their women, but rarely did they bring their wives." Patrons remember policemen visiting the Riviera's basement, which allegedly housed an illegal booking joint, and stuffing envelopes into their coat pockets on the way out. Milwaukee police suspected the Riviera of paying "insurance," but the Machi brothers denied being shaken down by any syndicate. (Both, Milwaukee County Historical Society.)

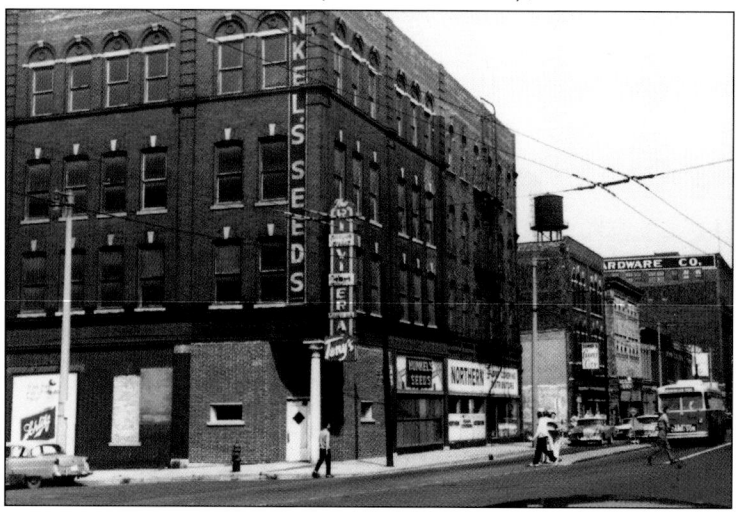

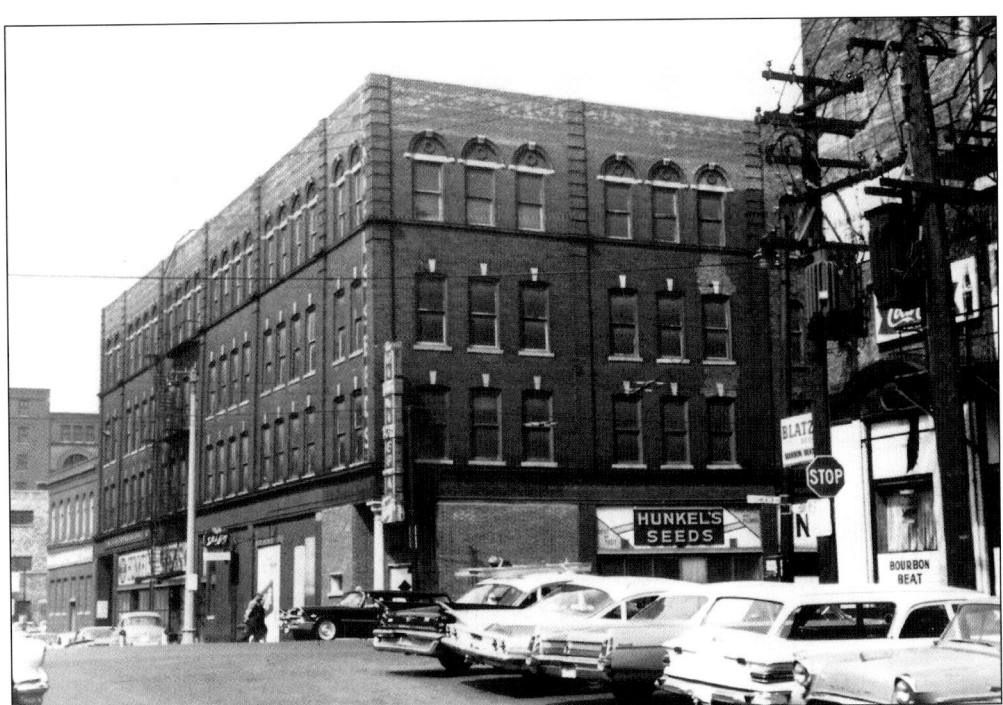

On March 14, 1964, a catastrophic five-alarm fire consumed the Riviera and devastated the block. "I was on vacation in California," said a contributor, "when someone called me to say 'your house is on fire—come home!'" At 6:00 p.m., someone ran into the bar and yelled "Fire!" Bartender Richard Isensee remained open until policemen ordered him to evacuate. "When we left, the ceiling was on fire," said Isensee. "But you just don't leave a dirty bar." The ruins smoldered for a week. Although arson was suspected, FBI documents note that the underinsured tavern was a "profitable fag joint." Rumor has it that a lovers' spat ended with one of the men setting fire to the building. The Riviera relocated to 952 North Plankinton Avenue until its 1967 demolition. Later, the Machi brothers opened Teddy's (1434 North Farwell Avenue), a disco and live music venue that is now Shank Hall. (Both, Milwaukee County Historical Society.)

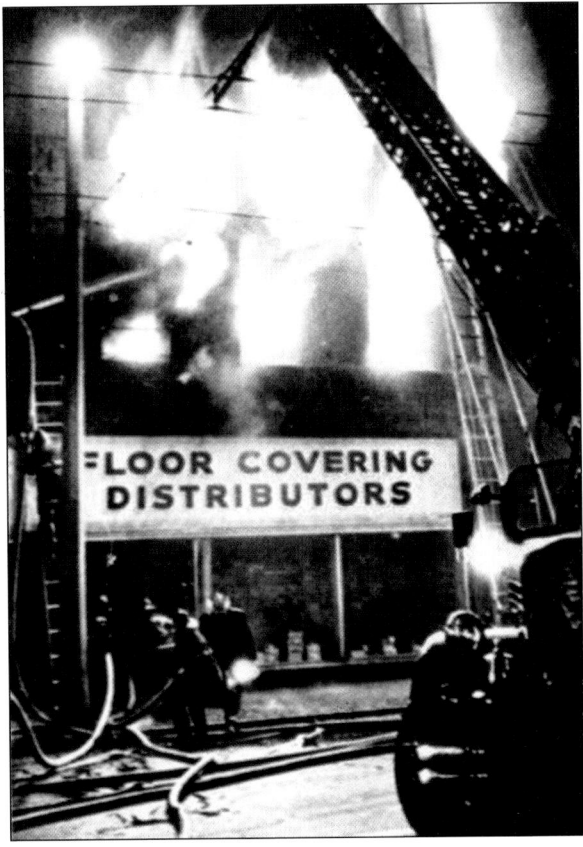

The Mint Bar (422 West State Street) holds the record for the city's longest-running gay bar. Open in 1949, a generation before Stonewall, the Mint was an early beacon for Milwaukee's gay men. It was a small, cozy bar, with only a few barstools and tables, but its size gave it a distinctive charm and unpretentious character that was larger than life. New Year's Eve, especially, was always a big night out at the Mint. Angelo Aiello started working at Tony's Mint Bar in 1958 and took ownership in 1961. As beloved community icons, Angelo and his wife, Bettie, managed the Mint Bar for over 25 years. (Both, Bunny.)

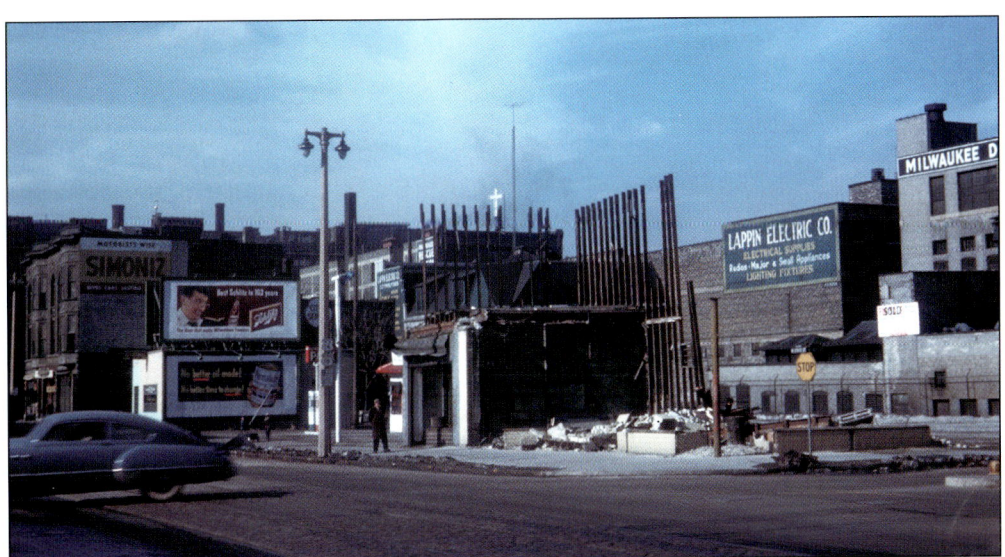

In 1971, the Mint Bar started promoting itself as a "male bar" and later "Milwaukee's original gay bar." Angelo Aiello's long-term success inspired everyone from upstart Walker's Point bar owners to the Balistrieri family, who sought to duplicate Angelo's success at other venues. Looking back, it is amazing that the Mint survived almost 50 years in the heart of the convention center district. Slowly but surely, every other historic building in the 400 and 500 blocks of State Street was eliminated for parking. Eventually, only the Mint Bar and the neighboring McDonald's remained. The Mint Bar was sitting on prime real estate that was quietly skyrocketing in value. Milwaukee began to notice. (Both, Wisconsin LGBT History Project.)

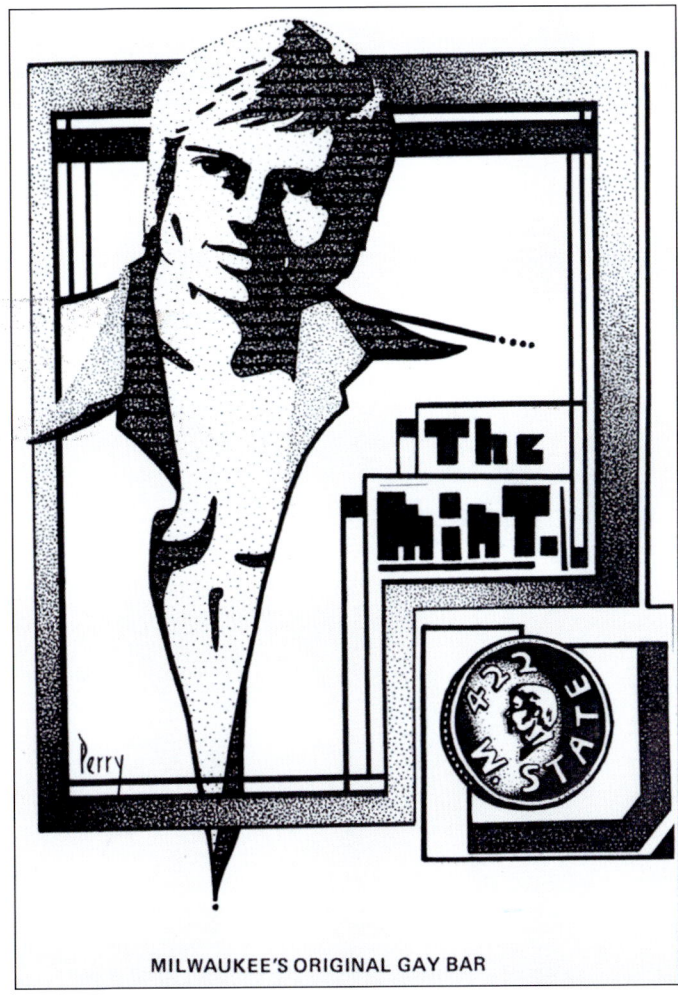

MILWAUKEE'S ORIGINAL GAY BAR

When the $53 million multi-block Bradley Center project was proposed in 1985, the Mint Bar was one of seven properties acquired for the site. The Mint Bar, one of two buildings left standing on its block, sold for just $92,900. On June 28, 1986, the Mint hosted a wake for its State Street location, complete with black wreath, black balloons, tombstones, and a "Rest in Peace" banner. More than 300 attended the ceremony in black armbands. Bettie promised a resurrection party when the Mint Bar reopened as its new address (819 South Second Street). The rebirth was short-lived. After the Mint's 40th anniversary party in May 1989, the bar's popularity dwindled. Bettie sold the business in 1991 after 30 years of service. The bar was renamed BJ's and closed two years later. (Both, Wisconsin LGBT History Project.)

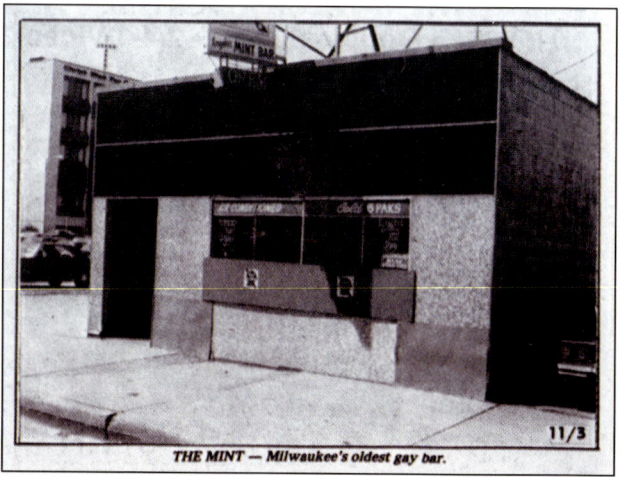

THE MINT — Milwaukee's oldest gay bar.

As early as 1964, Swittel's Tap (1187 North 68th Street) was listed in national gay guides for its secret upstairs bar, Jimmy's Hi-Fi Lounge. Accessible only by password ("I'm looking for the red room") through a green door, the Hi-Fi Lounge was an unexpected venue for the Wauwatosa Village. While downstairs was a standard pool hall, the second floor was far more exotic, serving up fancy martinis, hip music, and an attractive crowd. (Wisconsin LGBT History Project.)

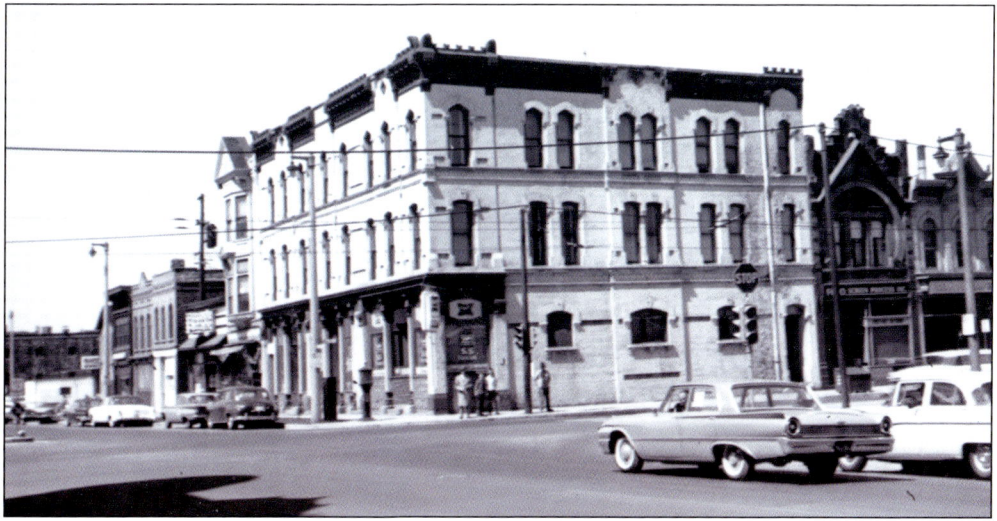

When the Grand Prix Lounge (144 East Juneau Avenue) opened, Water Street was still a skid row. Prior to the 1968 opening of the Performing Arts Center, gay guides cautioned visitors about this "rough area." Decorated with Al Hirschfield caricatures, the Grand Prix was a popular neighborhood bar until 1971. Now, this is the site of Art's Performing Center. (Milwaukee County Historical Society.)

Surrounded by tanneries, coal yards, and a polluted river, the Gettelman Brewery tavern at 1758 North Plankinton Avenue was originally a workingman's hangout. Little is known about the Regency East (1963–1970) except that it was a semi-elegant bar with watered-down drinks, in a less-than-elegant neighborhood where muggings were common. Replaced by a scandal-ridden "syndicate bar," the Regency East is now Trocadero. (Milwaukee County Historical Society.)

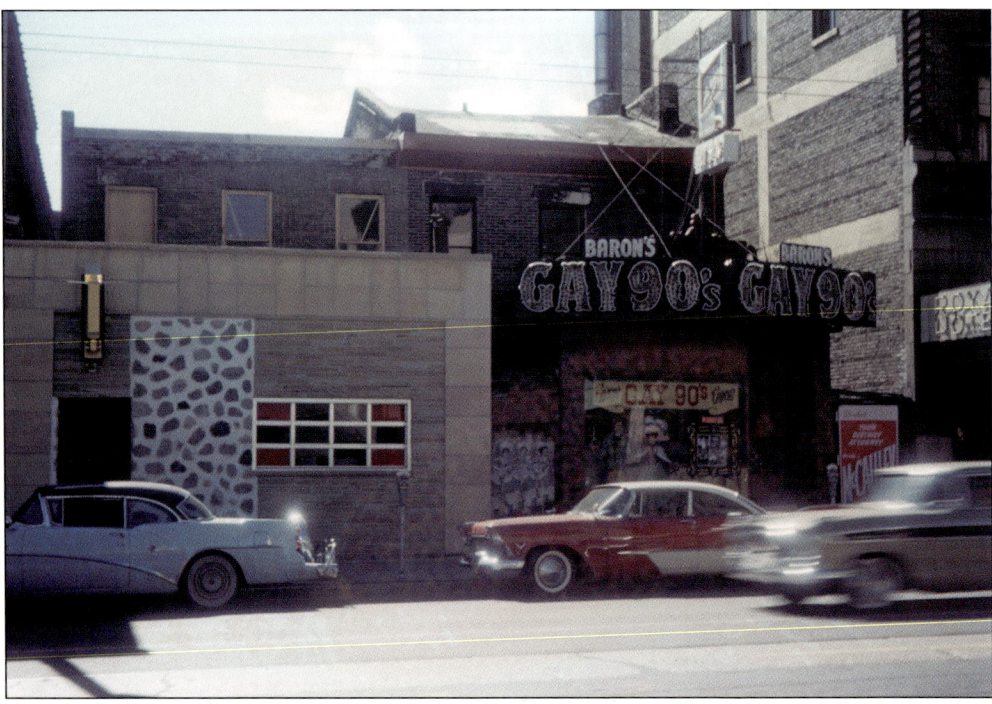

Although "gay" had a very different meaning at the time, Baron's Gay 90's (Fifth and Michigan Streets) offered show tunes, live piano, vaudeville, and Parisian cabaret that attracted gay regulars from the neighboring Royal Hotel. Baron's opened at 752 North Plankinton Avenue in 1952 and moved to Fifth Street from 1958 to 1966, when it was razed for Royal Hotel parking. (Milwaukee County Historical Society.)

The aging Pfister Hotel (424 East Wisconsin Avenue) was "squaresville" by the 1960s. Out-of-state owners, cashing in on *Spartacus*, debuted an atmospheric 1,200-square-foot lounge on June 15, 1961. With stunning Roman grandeur, the Columns featured centurion doormen, toga-wearing waitresses, neoclassical murals, nightly entertainment, and volcanic cocktails. Gay men found it glorious; critics found it tacky. In 1970, the Columns became Café Ole. (*Milwaukee Journal Sentinel*.)

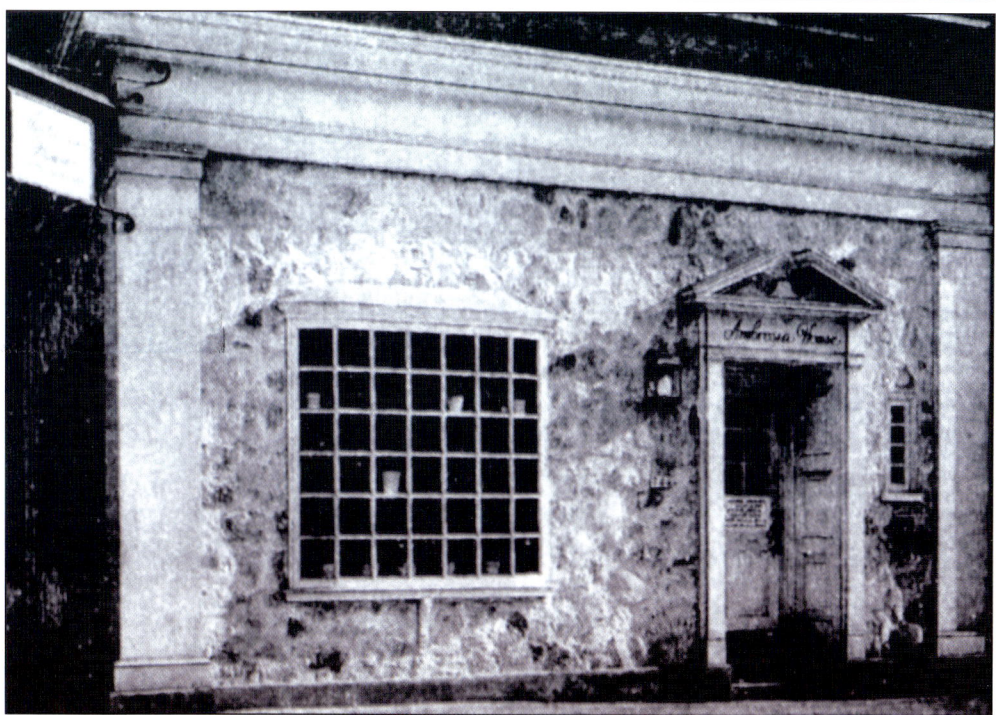

In 1960, the Seaway Inn (744 North Jefferson Street) opened in the former Ambrosia House, Wisconsin's first vegetarian restaurant. Owner Otto Schuller transformed the elegant stone cottage into a cozy, 20-stool fireside lounge famous for "Christmas In July" parties. Razed for parking in 1972, the Seaway Inn moved to 173 South Second Street (formerly the Black Knight) until 1977. (Wisconsin LGBT History Project.)

In 1968, June Brehm was shopping for a downtown bar. While touring the tiny tavern at 418 East Wells Street, June took one look and said, "This is it. We aren't going anywhere else." This Is It was born. "My mother knew a lot of gay people, and she wanted a bar and grill for them to call their own," explains Joe Brehm. Until the 1980s, few people even used the front door. Men entered through the alley and stayed close to the back. The bar rarely saw female customers. "We kept the lights half as bright as now. If the front door opened, everyone's heads would turn at the same time. If you saw someone you didn't want to see, you beat it out the back door before their eyes adjusted." (Both, Wisconsin LGBT History Project.)

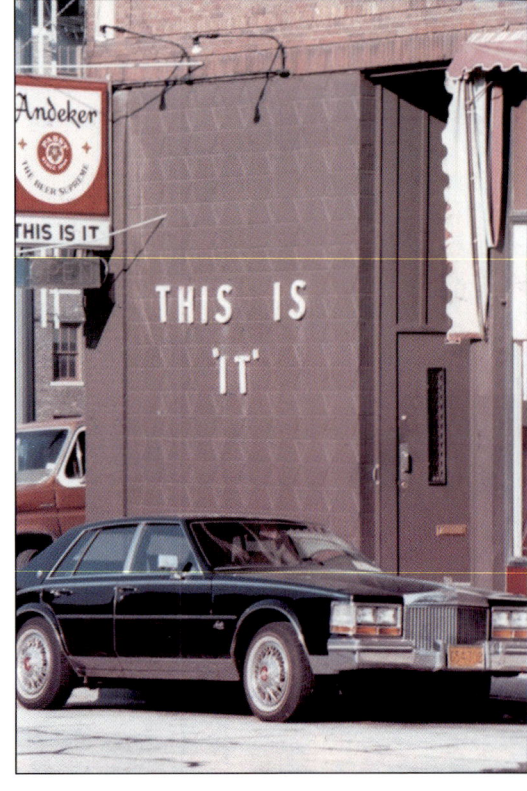

This Is It went without signage for so long that most patrons thought it was always a "secret" bar. Actually, the facade was originally signed with large metal letters. After years of dealing with pranksters rearranging the letters, the bar owners just gave up and removed them. After closely managing the business for four decades, June Brehm passed away in 2010 and Joe Brehm in 2016. Their lasting legacy to Milwaukee's LGBTQ community will be forever commendable. Now the longest-operating gay bar in Wisconsin, the award-winning and ever-evolving This Is It approaches its fifth decade stronger than ever. "Over the years, so many people have told my mother that she should write a book about This Is It, but she'd never do it," said Joe Brehm. "She loved them all too much to do that to them." (Above, *QLife News*; right, Wisconsin LGBT History Project.)

Opened in 1960 at 901 West National Avenue, the Nite Beat was the first lesbian bar to open on the South Side. It is remembered as an old-school, no-nonsense "diesel" bar heavy on butches and light on femmes. Regulars were skeptical of women who did not fit traditional roles. "Carrie ran a tight ship," remembered a contributor. "No fighting, no arguing, no nonsense." From 1962 to 1968, Nite Beat was located at 196 South Second Street. In 1969, the bar moved across the street to 183 South Second Street. After reinventing itself every year (New Riviera in 1972, Carrie's in 1973, Dionysus in 1974), the venue was destroyed by arson on April 22, 1974. According to legend, a drag performer, fired from the Dionysus show, set fire to the bar in revenge. (Both, Wisconsin LGBT History Project.)

Closed Monday
Tues. — Sat.
6 PM till closing
Sunday —
4 PM till closing

Carrie & Stan

GIRL'S BAR nite beat 183 So. Second St. 272-9268

Well known in the bar business, Albert "Al" Barry knew an opportunity when he saw one. Inspired by the new wave of Fifth Ward gay bars, Barry acquired a turn-of-the-century shot-and-beer joint and opened the Rooster in 1969. Managed by Tiny and Ron, the Rooster (181 South Second Street) became "the place to be seen" in an ever-growing nightlife block. Reportedly, local crime bosses had their hands in Barry's till. Facing financial and legal challenges, Barry sold the Rooster in 1972 to focus on his more popular bar, the River Queen. Pictured are Mama Rae and Tiger Rose. (Wisconsin LGBT History Project.)

The Seaway Inn moved into the property for a year, followed by lesbian bars Carrie's and the Flame. Ironically, the Flame was scorched in the same 1974 fire that destroyed the Nite Beat. Six years later, Art Guenther reopened the abandoned bar as Just Art's Saloon, which remains a popular bar and grill today. (Wisconsin LGBT History Project.)

Built in 1853, the Cross Keys Hotel (400 North Water Street) once hosted Pres. Abraham Lincoln for a bath. Surrounded by warehouses "one sneeze away from falling over," the building seemed doomed. The Crystal Palace, a saloon specializing in banjo players and piano singalongs, attracted gay customers from the Plankinton Avenue strip throughout the 1960s. When Al Barry opened the River Queen in 1971, the Cross Keys was the last building on the block. Decked out in crystal chandeliers and red velvet, the River Queen is remembered as the finest lounge of its time, where Liberace, Milton Berle, Paul Lynde, and Carol Channing cocktailed. Unfortunately, the bar's license was in constant jeopardy, possibly due to its alleged affiliation with organized crime. Overwhelmed, Barry sold the business to James O'Connor in 1973. (Both, Wisconsin LGBT History Project.)

RIVER QUEEN
Docked at 402 North Water Street

Open 10 P.M. till closing – Friday,
4 P.M. – Sundays and Holidays open
2 P.M.

PLAN ON ATTENDING OUR
COSTUME DRAG BALL
Wednesday, Oct. 27th, 9 P.M.

$150 in cash prizes
plus bottled goods

Don't get left in the wake

In January 1976, the River Queen was the scene of a massive police corruption scandal. To avoid harassment, O'Connor had provided cash payoffs, expensive gifts, cases of liquor, and unlimited free drinks to over 50 policemen and their wives for years. Officers were allegedly served at the bar until 7:00 a.m. (by both bartenders and prostitutes) and sometimes fired bullets into the ceiling. Investigators traveled the Midwest to obtain shadowy testimonials, but the case was dismissed without charges. "Detectives say that homosexuals, like prostitutes, are often valuable sources of information about criminal activity," reported the *Milwaukee Journal*. The River Queen closed temporarily, and then closed forever. Although few patrons knew or understood the Cross Keys's glorious past, everyone wanted a piece of the River Queen. Some still own barstools to this day. (Both, Wisconsin LGBT History Project.)

The Club Health Spa for Men

225 E. St. Paul Ave.　　　271-3469

24 hours daily - 7 days per week

THE MIDWEST'S MOST ELABORATE BATH, FEATURING: PRIVATE ROOMS, LOCKERS, STEAM ROOM, EXERCISE ROOM, TV LOUNGE, GAME ROOM, DANCING, FOOD AND DRINK, AND A SUN ROOM.

Pick up your identification cards at the River Queen

THE RIVER QUEEN

402 North Water Street, Milwaukee　272-0150

BEER BUST TUESDAYS
THURSDAYS AND
SUNDAYS

After the legendary River Queen closed, a revolving door of gay bars—including Sharon's, Side Door, and Jocks—came and went. By 1979, the building's sole occupant was the Waterfront Café. On November 28, 1979, a three-alarm fire broke out at the Cross Keys at 4:15 a.m. The fire started on the first floor, but the state fire marshal never found its cause. Over 100 firefighters battled to save the building, but it was a total loss. Inspectors noted the former hotel lobby, once five feet above street level, had sunk five feet below street level since 1879. After 127 years of service, the oldest building in Milwaukee was razed in May 1980. The land remained vacant until 2005, when the Milwaukee Public Market was built on the Cross Keys Hotel footprint. (Both, Wisconsin LGBT History Project.)

In 1965, Jim Dorn opened Your Place (813 South First Street) with lover Jerry Stinson. When most gay bars were located downtown, "the Y.P." was a pioneer in Walker's Point. The name "Your Place" was chosen code that allowed more discrete social planning. "Big enough to 'party,' but small enough to do your own thing," Y.P was the first gay bar to have a landscaped outdoor patio and a lighted dance floor. "Mother Dorn" was known for generously caring for homeless and rejected gay youth. Wayne Bernhagen (later of Wreck Room) became manager after Stinson exited the business. Dorn sold Y.P. in 1982. After a series of owners, the bar was renamed Partners from 1989 until 1993, when owners briefly resurrected the name Your Place. Since 1994, the former Y.P. has been a gentlemen's club. (Both, Wisconsin LGBT History Project.)

Two

Time for Liberation

Mickey's Cove opened at 157 South First Street in 1972. It was the first of six LGBTQ bars that opened in this historic 1862 meat market. Outside the Fifth Ward "loop," the Cove marked the beginning of a 1970s Third Ward migration. The bar closed six months later and reopened as the Backroom, but the Cove was briefly resurrected in 1974. (Wisconsin LGBT History Project.)

> When Traveling By Bus
> Visit "Fat Jack" at the Bar
> 11:00 am Till Closing
>
> **THE HUNTER'S CLUB**
> 645 N. 7Th
> Transits 273-2710

Milwaukee's modern Greyhound station opened in 1964. By 1969, gay guides listed Alex's (644 North Seventh Street), a basement pickup place in the adjacent Clark Building. Hunter's (645 North Seventh Street) opened in 1970. "These were some of the most shameless cruising bars ever," said a contributor. "People were going at it, in the bar, only blocks away from the police department." (Wisconsin LGBT History Project.)

The Neptune Club, opened on May 27, 1972, at 1100 East Kane Place, formerly Fish's Harbor Tavern. It was the first gay bar opened by club king Chuck Cicirello. Although popular for drag shows and dance music, the Neptune closed in 1973 when Cicirello opened legendary disco the Factory. 1100 East Kane was later popular as the Landing and the Tasting Room (1993–2007). (Wisconsin LGBT History Project.)

THE Beer Garden
3743 WEST VLIET • MILWAUKEE

NOW OPEN 7 DAYS A WEEK
INCLUDING ALL HOLIDAYS
(EXCEPT THANKSGIVING AND CHRISTMAS)

LUNCH FROM 11AM
TUESDAYS—BEER MUG NIGHT

SUNDAY BRUNCH
11–4PM

*FRIDAYS—FISH FRY
ROAST BEEF SANDWICHES
WITH POTATOES & GRAVY*

Beer Garden (3743 West Vliet Street) was a heartfelt home for Milwaukee's gay women from 1966 on. It was located on the fringe of Washington Park, a neighborhood that was in continuous transition from the day the bar opened. Owners Roger and Sally are remembered for their hospitality, generosity, and goodwill. "Everyone I know in Milwaukee to this day, I met at the Beer Garden," said a contributor. "It was our living room, our kitchen, our everything." The Beer Garden sponsored bowling, softball, and other sports leagues, bringing hundreds to the bar every weekend. New owners, challenged by neighborhood crime, closed the business within years. When the bar was razed, patrons took its bricks as souvenirs. "When I look at that tiny lot, I still wonder how we fit so many people in there." (Wisconsin LGBT History Project.)

Previously the site of Nite Beat II, Castaways South, and (very briefly) Jamies, 196 South Second Street was already a gay landmark when Ball Game opened here in March 1974. New owners Gene O'Brien and Rick Kowal remodeled the bar with a sporty new theme, promising customers would "never strike out." For the next four decades, Ball Game sponsored innumerable sports teams, hosted an array of stage performances and pageants, and supported critical community causes. Ball Game was one of the first bars to mobilize during the AIDS crisis, raising countless dollars for AIDS/HIV research and prevention. Caring and compassionate for its customers, Ball Game served generous holiday buffets so that everyone had a place to celebrate the season. The bar's anniversary parties, held on St. Patrick's Day, were legendary events. (Wisconsin LGBT History Project.)

THE BALL GAME
The Ball Game is a very comfortable and relaxing bar with a mixed crowd. With pinball and pool, and a secluded dance floor.

Gentrification arrived in the Fifth Ward in 2005. As nearby bars closed, gay nightlife moved south to National Avenue. Ball Game, despite its retro charm and character, was cast adrift with a transitional neighborhood, aging clientele, and changing times. The bar, always known for cocktail hour, now struggled to maintain all-night business. Although a For Sale sign went up on the building in 2012, staff still denied the bar was closing. On August 19, 2012, the bar announced its closing on Facebook, and fans were invited to "drink till it's gone" at a farewell celebration on August 21. After the bar's historic collection of gay memorabilia was raided, heartbroken owner Rick Kowal closed the bar forever on August 20, 2012, ending 50 years of LGBTQ nightlife at this location. (Wisconsin LGBT History Project.)

After working 25 years in a factory, Clarence Germershausen (a.k.a. John Clayton) opened C'est La Vie (231 South Second Street) in December 1974. Incredibly, C'est La Vie was one of seven gay bars in a one-block radius at the time. "If you drive south on S. Second St. . . . it will appear as though you are driving into a canyon with no other way out," warned a *Milwaukee Journal* article. C'est La Vie was known as a pickup place for older men to cruise younger men. The bar specialized in hiring the young and attractive, including doormen, bartenders, and dancers. "Chicken Night" welcomed 18-to-20-year-olds for a special Saturday happy hour, followed by "Tricking Hour" with 25¢ drinks and a free Sunday buffet. "Dirty Old Man" night encouraged 40-plus customers to leave their clothes on for free beer. (Both, Milwaukee County Historical Society.)

When bar, boardinghouse, and barely legal are combined, trouble follows. After 1978, C'est La Vie became the target of continuous police harassment. Clayton reported that officers would drive by, yelling "faggot," "queer," "she-male," and other insults. Undercover detectives, posing as lovers, rented rooms in the building to build a case. After losing his license in 1981, Clayton and his mother filed a harassment suit. The bar remained open. C'est La Vie's audience shifted in later years. It became known as a safe and welcoming space for every gender expression, in a way unlike any bar before or since. Although John Clayton passed away in August 2005, his dream survived three more (smoke-free) years. After a May 3, 2008, farewell show was announced and then abruptly cancelled, C'est La Vie simply ceased to exist. Now it is Zak's Cafe. (Both, Wisconsin LGBT History Project.)

"If you want to make it, make it at the Factory." Who could resist? As Milwaukee's answer to Studio 54, the Factory (158 North Broadway Street) was, and is, the most famous local nightclub. Open in 1973, the Factory was disco perfection *before* disco. With 2,400 square feet of space, soaring ceilings, light shows, celebrity DJs, a pulsating dance floor, and a smoke-snorting, sinister devil head above it all, the Factory was an absolute adult funhouse. Customers could boogie with the devil, flirt across the bar via tabletop phones, enjoy wild drag shows in the Loading Dock, or explore the Broadway Health Club bathhouse upstairs. The Factory lost its lease in 1982. After two attempts to relocate elsewhere, the Factory closed in 1988. Today, the original Factory is home to the Broadway Theatre Center. (Above, Wisconsin LGBT History Project; below, Bunny.)

The Wreck Room (266 East Erie Street) was Milwaukee's first cowboy/Levi-and-leather bar. Opened in July 1972 by Wayne Bernhagen, the macho bar had a rustic but tasteful theme. The Wreck Room is remembered for its unique architecture, including the entire front end of a Thunderbird, a hand-carved wooden penis cart, salvaged hubcaps, leather bar memorabilia, a very naughty backroom, and "the Cell." After many years of hosting extravagant anniversary parties, the Silver Star Motorcycle Club and Wreck Room Classic softball invitationals, owner Wayne Bernhagen died in 1987. Between the AIDS crisis, a changing Third Ward, and emerging nightlife options, the bar was being crowded out. Its 22nd anniversary celebration would be its last. Wreck Room was converted to a MIAD student center in 1995. (Both, Wisconsin LGBT History Project.)

LEADED SHADE
The Leaded Shade, not only a popular bar with women and men, is also a fine place to eat, from snacks to full course meals.

Open Daily from 3:30
Serving food at all times

THE LEADED SHADE
157 South First Street · 278-9563

The Leaded Shade (157 South First Street) replaced the Cove with a more upscale experience than Milwaukee's lesbians ever expected in 1974. With classier décor, softer lighting, a late-night restaurant, and live entertainment, the Leaded Shade was the women's high-end choice. Closed in 1979, the bar became First Street Station until the 1990s and is today being converted to a single-family home. (Wisconsin LGBT History Project.)

The Finale (808 East Center Street) opened in Riverwest at the height of gay liberation. Owned as a small neighborhood bar, the Finale was immediately popular, expanded quickly, and became known as a single-stop bar that customers just did not leave. Some were rumored to stay overnight at "lock-in parties." The Finale was ravaged by fire in January 1986 and never reopened. (Jamie Taylor.)

What happens when a long-running family tavern "goes gay?" In April 1975, Martin's (1800 North Arlington Street) began inviting gay men to "Meet him at the M!" Suggestive *GPU News* ads beckoned to bon vivants seeking a space to be themselves. Martin's closed in 1976 when the bar was sold after four decades of family ownership. Jamo's has operated here since 2002. (Wisconsin LGBT History Project.)

"Women—you asked for it! A bar owned and operated by and for women!" read the ads for the Sugar Shack (135 East National Avenue), which opened in June 1976. The Shack was a long-running landmark. "Women, women, women and lots of room to mingle," read the gay guides. Sugar Shack became D.K.'s in 1985 but is best known as Triangle (1988–2012). (Wisconsin LGBT History Project.)

55

Since 1954, the Empire Lounge (716 North Plankinton Avenue) was a classic piano bar with sophisticated ambience, where refined gay men quietly met over manhattans. Seeing profit potential, the Balistrieri family acquired the property in May 1975, sold off the piano, and relaunched the lounge as a more flamboyant gay bar. Somehow losing its flair, it lasted less than a year. (Milwaukee County Historical Society.)

Opened in June 1966, the Ad Lib (323 West Wells Street) featured America's best jazz performers, including Dizzy Gillespie, Thelonious Monk, and Miles Davis. A year later, the Balistrieri-owned cabaret switched to $1 striptease shows starring female impersonators. Defying both gender and exposure laws, transgender star Misty Dawn mystified a mix of clueless straights, gays, vice cops, and FBI detectives. The venue closed in 1975. (Wisconsin LGBT History Project.)

The Red Baron (625 East St. Paul Avenue) was one of Milwaukee's earliest discos. A few walkable blocks from the Factory and River Queen, "Milwaukee's Disco Ace" was very popular with gay men. On March 4, 1978, Grace Jones made her Milwaukee premiere here, riding a motorcycle onstage in a silver jumpsuit. It was probably the Red Baron's finest hour. Although disco was an inclusive music movement that celebrated unity, the Red Baron was criticized for its selective door policies. Complaints charged that black customers were turned away and gay customers were charged extra. In April 1980, the club was sold to a local group who sought to attract a young, black clientele to a renamed the Baron. Outdone by Park Avenue and the Factory, the Baron closed by 1982. (Wisconsin LGBT History Project.)

THE BARON

YOUR NITE CLUB / 625 EAST ST PAUL / MILWAUKEE, WISCONSIN

FEATURING:

SUNDAY	Free Hot Dogs and Nickel Beer 9 p.m. til 11 p.m. Also, Disco Request Nite.
MONDAY	Half Price Drink Nite
TUESDAY	Half Price Drink Nite
WEDNESDAY	Beer or Bust — — $2.00 ALL BEER, WINE and SODA YOU CAN DRINK
THURSDAY	Dance Contest — $100.00 First Prize Sign up for contestants between 10:30 and 11 p.m.
FRIDAY	Disco Mania
SATURDAY	"HOT" Disco Music ALL NITE

COMING ATTRACTIONS

1. Thursday Nite, September 22nd — Fabulous Fiftys Nite

OCTOBER

1. MR. BARON CONTEST
 1st prize: TRIP TO ACAPULCO FOR TWO
 2nd prize: $100.00
 3rd prize: $50.00
2. Theme Parties Year Round
3. Excursion Trips
4. Restaurant On The Lower Level

NOTE:
[Don't forget to pick up applications for the Mr. Baron Contest.]

Oregon House (235 South Second Street) arrived on the ever-growing gay block in July 1976. Paved entirely in shag carpet and wood paneling, the non-disco missed the mark until it added a backroom dance floor, the Loading Dock. Vacant two years, the bar reopened as Phoenix in May 1979. The Phoenix enjoyed a 14-year run as a cornerstone of the Second Street circuit. (Wisconsin LGBT History Project.)

"Chicago has nothing like it. San Francisco has nothing better. New York has no gay restaurant that can surpass Shadows." When Shadows (814 South Second Street) opened in 1980, the national gay press praised its top-shelf "Diplomat Dining" experience. It was the first Milwaukee restaurant where men could hold hands. Closed in 1984, Shadows made a brief comeback from 1987 to 1989. (Milwaukee County Historical Society.)

219 South Second Street probably hosted more gay bars than any Milwaukee address. Gallery Lounge opened in September 1974 as a simple speakeasy with jukebox and game room. Six months later, it was Gary's Disco, a "bizarre place to boogie," followed by the mysterious Mr. Z's. After three forgettable bars in 18 months, the venue seemed cursed. Circus changed everything in July 1976. Out went faux Tudor décor, stained glass, and wood paneling. In came extraordinary light shows, powerful sound systems, and wall-to-wall mirrored everything. "Disco up, lounge down, drinks in the middle," was its motto. Circus mesmerized gay Milwaukee, and its smashing success gave the Factory serious competition. New owners converted Circus to a gay-only membership club in November 1978. It lasted a year. Trash, its blink-and-you'll-miss-it replacement, lasted only months. (Both, Bjorn Olaf Nasett.)

In February 1981, Club 219 opened, ushering in the age of the superclub, featuring world-class drag productions, strippers, live entertainment (including Divine in March 1988), high-energy DJ shows, and sensational New Year's Eve parties. The bar welcomed amateur strippers and drag queens to audition—with audience participation—every week. Fierce competition between 219 and La Cage fueled a decades-long rivalry for talent, business, and press. Unfortunately, Club 219 received unforgettable press when identified as a hangout of serial killer Jeffrey Dahmer. The bar held its head high and survived the crisis, but it could not survive the new menace of Fifth Ward gentrification. After three decades as an LGBTQ destination, 219 South Second Street went dark in October 2005. It has been dark ever since. (Left, Bjorn Olaf Nasett; below, Wisconsin LGBT History Project.)

Bob Schmidt and his partners celebrated the bicentennial by opening M&M Club (124 North Water Street) on July 4, 1976. The true meaning of "M&M" remains shrouded in mystery. The bar opened shortly after Milwaukee officials vetoed rezoning the Historic Third Ward as a red-light "combat zone." The former Pabst Brewing Co. saloon, built in 1904, was restored to life with a sophisticated, but sensible, new ambience that drew gay men and women in equal numbers. With professional singers, pianists, and other musicians performing, the M&M was often a theatrical experience. In 1977, the M&M introduced the longest-running LGBT restaurant in Milwaukee. First known as the Sideboard, and later the Glass Menagerie, the seven-days-a-week operation offered famous fish fries, Sunday brunches, and holiday dinners in a brilliant glass atrium. (Both, Wisconsin LGBT History Project.)

The "open window" gay bar has finally hit Milwaukee, as shown here at M&M club.

In 1984, M&M Club became the first Milwaukee gay bar to open large picture windows to the street. Coincidentally, but not surprisingly, the Historic Third Ward began a long, wild gentrification that continues today. As the neighborhood went upscale, the 1980s "Fruit Loop" disappeared. By 1995, M&M was the last gay bar in the area. Bob sold the M&M in 2002 to a longtime employee, but business was already declining. After announcing its closing, the M&M hosted an emotional, week-long "Last Call" party. The bar went dark on Sunday, May 14, 2006. The M&M's legacy briefly continued at M's (1101 South Second Street), a successor that opened in October 2006. Featuring some of the same staff, performers, and clientele, M's sought to recreate the M&M experience in a new space. The bar closed in 2010. (Above, Brian Buchberger; left, *QLife News*.)

In late 1970, the first 24-hour gay bathhouse in Milwaukee quietly opened on the East Side. Club Finlandia (707 East Knapp Street) advertised Roman pools, Swedish massage, movie nights, and "Nite Owl" specials. For years, Finlandia fended off police raids with a private membership model. Aggressive police raids began in 1978 and the Finlandia was forced out of business in 1982. (Milwaukee County Historical Society.)

The legendary Club Baths (704A West Wisconsin Avenue) opened in June 1974. At the heart of liberation culture, the national chain was so popular that there were lines at 3:00 a.m. Club Baths reacted to the AIDS crisis with safe-sex requirements; however, many changes were considered a threat to sexual expression. Branded a public-health risk, Club closed in February 1988. (Wisconsin LGBT History Project.)

Three
CITY OF NIGHT

At the height of the *Saturday Night Fever* craze, Kisses (132 East Juneau Avenue) was a "disco delight" that opened daily at 9:00 a.m. Its advertisements, in both traditional and gay press, boldly proclaimed that it was "all gay and here to stay." Small and somewhat cramped in a bi-level space, Kisses attracted a mixed downtown crowd, but closed in 1980. (Wisconsin LGBT History Project.)

In November 1978, Park Avenue (500 North Water Street) opened in the Button Block building, an 1892 landmark and the former home of the Mad Hatter. The days of Drink and Drown Wednesdays, purple shag carpet, and psychedelic wallpaper were over. Park Avenue was an ultra-swank, multistory New York nightclub, unlike anything Milwaukee had seen, with three-story flashing light towers, lethal blender drinks, and surprise feather drops on the city's largest dance floor. Park Avenue reserved one night a week as a "gay night": Sundays. Described as a very private affair, Sundays produced exotic fantasy parties for the city's hottest people. After a million-dollar renovation, the venue reopened as Nitro in 1992, and later a series of restaurants. Milwaukee's former "it spot" will be redeveloped as a hotel in 2017. (Milwaukee County Historical Society.)

DAVE CHRISTIAN requests the honor of your body along with a hot date of your choice for the most spectacular summer party ever.

. . . . Please arrive early and plan to spend the entire evening with several thousand partying men.

. . . . CRUISE THE PARK is a theme fantasy party with different club areas dedicated to your favorite fantasy . . . i.e., leather, cowboy, college, macho, levis, muscles, punk, drag, etc.

. . . . CRUISE THE PARK guaranteed to exceed your wildest imagination.

. . . . Invitations must accompany each stag or couple.

. . . . Discretion is extremely important. Admittance without invitation is not permitted.

. . . Complimentary lavish buffet - All you can eat.
. . . Complimentary open bar - all night - All you can drink.
. . . Complimentary Check and Locker Room.
. . . Complimentary medicals.
. . . Complimentary back pocket preference scarves.
. . . Complimentary cigarettes.

Admission: $10.00 without costume
 5.00 with fetish costume

cum CRUISE THE PARK
 Milwaukee will never be the same.

Park Avenue
500 NORTH WATER STREET
MILWAUKEE

Disco was fading when Bobby Bell opened Papagaio (515 North Broadway Street) in December 1981. Inspired by crackling Rio nightlife, Papagaio spun—and hosted—the most groundbreaking 1980s acts. The bar's popularity increased with the opening of Underground, an upstairs live music venue. When the drinking age raised to 21, the bar reinvented as Club New York before closing in August 1987. (Milwaukee County Historical Society.)

"She's got sex appeal. Her name's Marilyn." Club Marilyn (788 North Jackson Street) opened in fall 1985 as a high-class, pink neon tribute to Marilyn Monroe. On opening night, Marilyn lookalikes beckoned from a white convertible. With stunning lighting, video and sound systems, and a Teen Night that connected a generation of LGBT youth, Club Marilyn was "*the* nightclub" until 1994. (Photograph by the author.)

67

Grand Avenue Pub (716 West Wisconsin Avenue) opened in June 1982. Today, the Westown location seems unusual, but at the time, the Pub had the Club Baths, Odyssey Books, and Norman Apartments as neighbors. The bar's patrons were usually coming or going from the Club Baths, with more than food and drink in mind. Before closing in 1987, the Pub struggled with leasing issues for years. At one point, the Wisconsin Avenue storefront was in such great jeopardy that the owners converted a second tavern. The Ding Dong Bar was converted into the Grand Avenue Annex (746 North Seventh Street) for four months until the lease was secured. Mickey's Dynasty, the shortest-lived gay bar in Milwaukee history, replaced the Annex for one month. Today, this is the site of Jim's Time Out. (Both, Wisconsin LGBT History Project.)

When Boot Camp (209 East National Avenue) opened in September 1984, it faced stiff competition from Wreck Room for the Levi-and-leather crowd. Forbidding, mysterious, and atmospheric, Boot Camp quickly became Milwaukee's leather culture landmark. The long run came to an end on May 18, 2011, when a fire devastated Boot Camp. The land remains vacant today, but the memories will last forever. (Wisconsin LGBT History Project.)

After launching the popular Sugar Shack, Sharon Dixon opened Fannies (200 East Washington Street) two blocks away in November 1982. "It was rare to see men," said a contributor. "Fannies was a true women's bar." On October 28, 1997, a fire ended Fannies's legendary run. Reopened as Pulse, Passions, and Jack's, the bar now serves a fierce EDM following as Studio 200. (Wisconsin LGBT History Project.)

KATHY'S NUT HUT

Milwaukee's Friendliest Neighborhood Women's Bar
(everyone welcome)

When Kathy Krau opened Sassy's, later the Nut Hut (1500 West Scott) in 1980, she did not expect to launch the longest-running women's bar in Milwaukee. Described as a welcoming neighborhood bar with a big heart, the Nut Hut ran for three decades before closing in February 2014. Kathy also owned Hot Legs (814 South Second Street), a women's video bar, from 1984 to 1987. (Wisconsin LGBT History Project.)

618 North 27th St., 931-9144

27TH ST. DANCETERIA

Believe it or not, Twenty-Seventh Street and Wisconsin Avenue was once a gay strip. Lost & Found (617 North Twenty-Seventh Street), a women's disco, operated from 1978 to 1984, and Essingers (826 North Twenty-Seventh Street) served gays since the 1950s. In August 1985, Chuck Cicerello opened 27th Street Danceteria (618 North Twenty-Seventh Street) an all-ages club raided for allowing dancing without a liquor license. It closed in 1987. (Wisconsin LGBT History Project.)

Staffed by infamous "Dirty" Helen Joslin, Ski Glow Café (1106 South First Street) was an eccentric 24-hour combination diner/launderette. Footsteps from the bars, Ski Glow became a favorite 1970s after-party spot. The diner was sold in 1986 and reopened as Walker's Point Café. With no IDs required, the café became an LGBT youth meeting and networking place before abruptly closing in 1998. (Jamie Taylor.)

Paradise Books (225 North Water Street) opened in 1974. When adult businesses were struggling to survive, Paradise thrived in the Third Ward, where a gay bar "Fruit Loop" and street hustler scene had emerged. By 1989, the 24-hour Paradise arcade grossed $1,000 a day in quarter tokens, far exceeding the video rental business. Exhausted by obscenity charges and undercover cops, Paradise closed in 2003. (Wisconsin LGBT History Project.)

"Milwaukee's men's bar for the 90s," Triangle (135 East National Avenue) opened in June 1988 after a decade of women's bars, including D.K.'s and Sugar Shack. Since Triangle opened at 6:00 a.m., it was extremely popular as a starting place, ending place, and after-party space. The bar was little more than a 1900 machine shop, but its outdoor patio was the scene of drag, fashion, and DJ events with electrifying ambience. Customers loved the bar's charismatic bartenders, cheap drinks, and no-attitude atmosphere. In 2011, Triangle was experiencing a remarkable rebirth. Electronic dance DJs were packing the bar with weekend crowds, culture, and energy similar to San Francisco's EndUp. Longtime owner James Marr died suddenly in March 2011, which eventually led to the bar's closing on April 28, 2012. (Above, Jamie Taylor; below, Melody Spesard.)

La Cage (801 South Second Street) opened on March 20, 1984. La Cage thought big from day one, offering complimentary happy hour hors d'oeuvres, two-for-one video games, and a seven-day video schedule. La Cage promised a place "Where You Can Always Be What You Are." For a while, the bar offered free drinks to anyone who came in drag. Within six months, La Cage doubled in size and became the city's reigning dance club. With over 500 customers every Saturday, the club attracted crossover crowds who had, until then, avoided being seen in gay bars. Many longtime customers started going to La Cage long before they were 21, either with fake IDs or no IDs whatsoever. "Getting into La Cage" became a rite of passage for anyone growing up gay in Milwaukee. (Both, Wisconsin LGBT History Project.)

"Whoever said that you could only depend on two things in life, death and taxes, forgot to include La Cage's remodeling projects," said Bill Meunier, publisher of *Wisconsin Light*." For 25 years, the bar generated newness and excitement through nonstop transformation. In 1998, La Cage completed a $750,000 facade restoration that returned the building to its 1887 landmark appearance. Original owners George Prentice and Corey Grubb retired in November 2005, and the bar passed into new ownership. "Lots of people see this as just a club. They don't realize what being gay in Milwaukee would be like today if there hadn't been a La Cage," said Jackie Roberts, a longtime performer. "Bars come and go, but La Cage is a timeless chameleon: it transforms, adjusts, and adapts to whatever's happening at the moment." (Wisconsin LGBT History Project.)

As Milwaukee approached the millennium, new bars—with new energy—began to open in landmark spaces. In February 1999, Orbit (739 South Second Street) opened in the former Albermart, a corner pharmacy turned organ piper bar. Remembered for its purple exterior, pink elephant ride, electronic music, sci-fi murals, and elaborate theme parties, Orbit created unique and exciting ambience until closing in 2003. (Jamie Taylor.)

As local legend has it, the bar formerly known as Mugshots "came out" as a gay bar in May 1999. For nine years, Switch (124 West National Avenue) was famous for shirtless bartenders, exotic dancers, guest DJs and karaoke—and infamous for its patio foam parties, which some guests attended clothing optional. Switch closed in July 2008, but reunion parties continue. (Wisconsin LGBT History Project.)

Built by the Miller Brewing Company, the storied 1907 saloon at 117 East Greenfield Avenue was on its ninth life when Harbor Room opened in June 2000. Famous for offering half-priced drinks to shirtless men, the Levi-and-leather bar quickly drew loyal crowds and steamy Mr. Harbor Room contestants. Beautifully remodeled, Harbor Room remains as popular today as it was 15 years ago. (Wisconsin LGBT History Project.)

Julia LaLoggia opened Dish (235 South Second Street) in early 1998, transforming the former Phoenix space into a high-energy dance bar for women. As intense as it was inspiring, Dish became a national DJ destination with house and techno downstairs and trip-hop in the upstairs B*Side lounge. For years, Dish was the premier electronic dance club in Wisconsin, but the party ended in 2003. (Jamie Taylor.)

The 1880 tavern building at 819 South Second Street had been home to many gay bars, from Decision (1976) to the second Mint Bar (1986), to Zippers (1993). None of these had anywhere near the lasting power of Fluid, which debuted in July 1998. Opened by two popular Triangle bartenders, Fluid kicked off a "cosmo craze" with its unique martini menu and weekly drink specials. Located next to La Cage, Fluid is a starting point and ending point for weekend partiers making the rounds. The bar is deeply involved with the Walker's Point and LGBTQ communities, sponsoring events, fundraisers, sports, and the Pride Parade. Adding a lush outdoor patio, Fluid recently doubled its space and its charm. From Drag Queen Bingo to Darts Night, patrons never know what might happen next. (Both, Wisconsin LGBT History Project.)

By the 1990s, there were two gay bar districts on South Second Street—the older circuit around Pittsburgh Avenue, and the newer circuit around National Avenue. Between the two, there wasn't much. That changed with the arrival of In Between (625 South Second Street), which stood halfway between La Cage and 219 from 1995 to 1999. In February 2000, Club Boom opened with a bang. Within four years, the bar had expanded into the adjoining building, a more modern, bright, sleek neon experience renamed Room. Boom and the Room will be remembered for their porn star parties, which brought many international stars to Walker's Point for bar-top performances. As Walker's Point began to gentrify, Boom's business declined. After being sold in late 2014, the property is being converted to restaurant use. (Wisconsin LGBT History Project.)

The Sydney Hih Building (300 West Juneau Avenue) survived Park East freeway construction to become an unusual artist collective. Its basement bar, long known as the Mineshaft, was briefly reinvented as the Goldenshaft in 1984 and, later, as the Unicorn. The Unicorn did not last long as a gay bar, but it became historic as a live music venue. Smashing Pumpkins, Nine Inch Nails, Nirvana, and Soundgarden played here, as did formidable techno acts during the Deep Tunnel Project parties. On November 22, 1997, the basement bar became the Milwaukee Eagle, a men's leather club with intense electronic music. The Eagle hosted the area's largest leather contests, mainly in the "Shaft Club" members-only room. Losing crowds to Walker's Point bars, the Eagle closed in 2001. The Sydney Hih was razed in 2012. (Both, Night at the Unicorn © 2013 Christopher Robleski, Fading Nostalgia.)

Out-N-About (1407 South First Street) opened on August 1, 2003, at the former location of Who's On First. Originally a women's bar and grill, Out-N-About served a full menu, including a popular Friday Fish Fry. In 2005, the bar rebranded as MO'NA's, refocused on nightlife, and became one of the hottest dance clubs in town. Despite wildly busy Friday nights, MO'NA's closed in July 2012. (QLife News.)

"Lock up your daughters!" Walker's Pint (818 South Second Street) opened in 2001 as a casual women's space where every night was lady's night. Described as a little bar with a big personality, the Pint has created a family connection between staff and customers. In recent years, the bar has become a live music showcase for Milwaukee's most talented female artists. (Wisconsin LGBT History Project.)

1100 Club (1100 South First Street) opened in 1994 as a gay bar and grill. While popular with a leather crowd, the 1100 Club was brighter, friendlier, and more welcoming than the usual leather bar, and its shows and competitions attracted crossover crowds. Closed in 2003, the 1100 Club's location was home to an Internet café and series of eateries before becoming today's award-winning c.1880 restaurant. (Wisconsin LGBT History Project.)

When Jet's Place (1753 South Kinnickinnic Avenue) closed in May 1991, new owners Bob, Bobby, and Bruce reopened as 3B's, a line-dancing country-western bar. In June 1995, 3B's moved into the former Balkan Inn (1579 South Second Street), an 1880 tavern with secret Prohibition tunnels. In November 1997, Woody's opened as a sports bar offering darts, pool, and football beer busts. (Wisconsin LGBT History Project.)

In 1899, Milwaukee's harbor was among the busiest in the nation. Today's Kruz (354 East National Avenue) was built that year as a Pabst Brewing tavern to serve thirsty dockworkers. Previously Gargoyles (1995–1996) and South Water Street Docks (1998–2003), Kruz opened in November 2006 as a darker, edgier bar for men's men. With a steamy, tropical patio, Kruz keeps Milwaukee hot year-round. (Wisconsin LGBT History Project.)

ArtBar (722 East Burleigh) opened in March 2004 as a cozy clubhouse for Riverwest's creative energy. Gay owned and operated, the bar welcomes local artists, musicians, actors, filmmakers, and activists for craft cocktails and a revolving series of gallery installations. In 2011, ArtBar opened the neighboring TWO, a romantic "make-out lounge" that celebrates lovers of all kinds. (Wisconsin LGBT History Project.)

D.I.X. (739 South First Street) opened in 2009 in a landmark 1883 building that most Milwaukeeans remember as Timers Bar. Depending on the day of the week, D.I.X. has the feel of a Bourbon Street dance club, the creative energy of a New York nightclub, and/or the coziness of a traditional Milwaukee tavern. D.I.X. has become an anchor of modern gay nightlife. (Wisconsin LGBT History Project.)

Two former La Cage bartenders, one gay and one straight, opened Hybrid (707 East Brady Street), the city's newest and possibly last "gay" bar in March 2010. Hybrid's arrival on Brady Street marked a milestone in Milwaukee's LGBTQ history: bars no longer need to be entirely gay nor entirely straight, but are now welcoming to both equally without need for further definition. (Wisconsin LGBT History Project.)

Milwaukee Guerrilla Gay Bar launched in July 2007 with a mission to shatter the social status quo with a movable monthly takeover organized entirely through social media. On the first Friday of every month, the anonymous organization playfully invaded an unsuspecting straight bar with up to 300 followers. Originally subversive and controversial, MGGB became ironic as nightlife culture became more naturally inclusive. (Wisconsin LGBT History Project.)

Four

Postmodern Pride

The Gay Peoples Union (GPU) was the most important gay and lesbian rights organization of the 1970s. It founded the first community center, the first gay health clinic and hotline, and the city's first pride event. The GPU Mardi Gras Masquerade Ball drew 350 visitors to the Performing Arts Center on February 9, 1974, for comedian Michael Greer of *The Gay Deceivers*. (Wisconsin LGBT History Project.)

On September 10, 1988, the first-annual Milwaukee pride festival was held at Mitchell Park with the theme "Rightfully Proud." Planned by the Milwaukee Lesbian Gay Pride Committee, the event was also well attended by transgender and bisexual people. The Milwaukee Lesbian Gay Pride Celebration was the first in a continuous series of pride events leading to today's PrideFest. (Wisconsin LGBT History Project.)

The Milwaukee Pride Week Committee, a subgroup of GPU, began coordinating marches as early as 1981. However, the Milwaukee Pride March of June 17, 1989, is remembered as the largest gay and lesbian protest in the city's history. Over 500 men, women, and children marched two miles from Walker's Point to Cathedral Square, where another 500 had gathered for a rally honoring the 20th anniversary of the Stonewall Riots. For the first time, a Milwaukee mayor welcomed the crowds with support, as John Norquist encouraged marchers with the announcement "We are proud of who you are." (Wisconsin LGBT History Project.)

When PrideFest moved to Juneau Park in 1991, the event was still considered a political statement. Not yet a festival, but not a protest either, PrideFest now included a parade, guest speakers, entertainment stages, and food vendors. Attendance reached 7,000 visitors in 1992, exceeding the capacity of a city park and extending the event to two days in 1993. (Wisconsin LGBT History Project.)

After the 1989 Pride March, early pride parades followed a downtown route that started and ended at the festival grounds. Smaller in size, but no smaller in impact, than the earlier marches, the parades quickly grew to include local businesses, sponsors, and political leaders from across the state. (Wisconsin LGBT History Project.)

After shattering attendance records in 1993, the Milwaukee Lesbian Gay Pride Committee dissolved, and ownership of the event transferred to a new group, PrideFest, Inc. In 1994, the festival moved to Veterans Park, its first lakefront home, and expanded to include a dance tent, history tent, volleyball tournament, and classic car show. (Wisconsin LGBT History Project.)

PrideFest welcomed over 9,000 to live the dream in June 1995, with over 300 LGBTQ performers on four stages. "On June 10 and 11, you are free. Free to dance with whomever you want, free to hold hands with whomever you choose. FREE to be yourself." The festival celebrated the first same-sex commitment ceremonies with Wisconsin's largest wedding cake. (Wisconsin LGBT History Project.)

Only one year after moving to the lakefront, PrideFest had already outgrown its new home. Festival organizers began to negotiate a more permanent move. Over 100 people pooled their financial resources to form the "Proud Crowd." With their assistance, PrideFest was not only able to produce a remarkable experience in 1995 but also secure the move that changed the festival forever in 1996. (Wisconsin LGBT History Project.)

In October 1995, PrideFest Milwaukee received approval to rent a portion of Henry W. Maier Festival Park, otherwise known as the Summerfest grounds. While some questioned the move towards "corporate pride," most considered the move a significant victory. PrideFest was now legitimately part of Milwaukee's multicultural festival lineup—and became the first LGBTQ pride event in the world with permanent festival grounds. (Milwaukee Pride, Inc.)

In 1995, PrideFest offered the first-ever fireworks show of any LGBTQ pride event in the United States. "Light Up the Skies with Pride," sponsored by the Miller Brewing Company, included over 700 explosions produced by the Bartolotta company in the rainbow colors of the pride flag. Two decades later, this annual tradition continues at PrideFest Milwaukee. (Milwaukee Pride, Inc.)

Celebrating 10 years of Milwaukee pride, PrideFest 1997 was the first three-day-weekend festival. Over 12,000 visitors enjoyed national headliners Lea DeLaria and Bjorn Again, as well as "perfect" pink triangle fireworks over Lake Michigan. PrideFest also offered a brand new website, and festival photographs were posted on the Internet for the first time. (Milwaukee Pride, Inc.)

PrideFest has been observed every June for decades. Due to the 95th Harley-Davidson Anniversary Celebration in June 1998, PrideFest Milwaukee was rescheduled for late August. With steamy summer weather, the 1998 event broke attendance records with 14,478 visitors. After Pres. Bill Clinton declared June as Gay and Lesbian Pride Month in 2000, PrideFest returned to its original scheduling. Pres. Barack Obama extended the official observance of LGBT Pride Month in 2009. (Milwaukee Pride, Inc.)

The PrideFest 1998 welcome letter established a vision for a new century: "Often, people say that they wish PrideFest could last all year. They are referring not to the decorations, banners, music and crowds . . . They are referring to the feelings of being allowed to be exactly who they are. The festival is just three days, but pride should be all year round." (Milwaukee Pride, Inc.)

When PrideFest moved in 1996, the Wisconsin Pride Parade extended through the Historic Third Ward to the festival's front gates. It was funded entirely by donations, and pride flags were added to the parade route in 1999, making LGBTQ pride visible throughout downtown. Whether the event should be a festive parade or an aggressive march remained a hotly debated topic. (Milwaukee Pride, Inc.)

92

Having avoided bankruptcy in 2003, disastrous weather in 2008, and operational challenges in 2011, PrideFest Milwaukee celebrated its silver anniversary in 2012 with newfound focus, passion, and purpose. Mayor Tom Barrett (left) honored PrideFest president Scott Gunkel (right) and the festival's endurance by proclaiming June 8, 2012, as "PrideFest Day" in the city of Milwaukee. (Milwaukee Pride, Inc.)

The Miller Lite Mainstage has been home to many incredible acts since 1996, including Etta James, Cyndi Lauper, Joan Rivers, Wanda Sykes, Kathy Griffin, Margaret Cho, Andy Bell of Erasure, Ani DiFranco, Sophie B. Hawkins, Judy Tenuta, En Vogue, Belinda Carlisle, Patti LaBelle, Steve Grand, Salt-N-Pepa, Mary Lambert, Sandra Bernhard, Lisa Lampanelli, Natasha Bedingfield, and Joan Jett. (Milwaukee Pride, Inc.)

After several years of record-breaking attendance, PrideFest Milwaukee achieved an all-time high in 2016 with 33,438 visitors attending. In recent years, the festival has grown to meet the evolving needs of the community, adding stages for multicultural and women's music, an expanded health and wellness area, expanded services for youth and families, and multiple athletic events. As PrideFest approached its third decade, its leadership rebranded as Milwaukee Pride, Inc., a new 501(c)(3) nonprofit host for the festival and other community events. With a mission of educating the public about LGBTQ culture, celebrating the history and accomplishments of LGBTQ people, and fostering networking and outreach, Milwaukee Pride has achieved its longtime dream of sustaining a year-round community presence. (Above, Paví Gonzales; below, photograph by the author.)

About the Organizations

The Wisconsin LGBT History Project is a self-funded, community-driven project devoted to documenting the evolving face of local gay, lesbian, bisexual, and transgender life. Balancing a rich online resource with ongoing outreach exhibits, the project is committed to preserving stories, memories, and experiences not taught in history books.

The mission of **Milwaukee Pride, Inc.** is to educate both the general community and the LGBT communities about needs, issues, and various aspects of LGBT culture; to provide a forum to celebrate the history and accomplishments of LGBT people; and to create an environment for networking and outreach. As the host organization for PrideFest Milwaukee, Milwaukee Pride welcomes over 30,000 people to the city's lakefront for a three-day weekend celebration every June.

DISCOVER THOUSANDS OF LOCAL HISTORY BOOKS FEATURING MILLIONS OF VINTAGE IMAGES

Arcadia Publishing, the leading local history publisher in the United States, is committed to making history accessible and meaningful through publishing books that celebrate and preserve the heritage of America's people and places.

Find more books like this at
www.arcadiapublishing.com

Search for your hometown history, your old stomping grounds, and even your favorite sports team.

Consistent with our mission to preserve history on a local level, this book was printed in South Carolina on American-made paper and manufactured entirely in the United States. Products carrying the accredited Forest Stewardship Council (FSC) label are printed on 100 percent FSC-certified paper.

MADE IN THE USA